IMAGES
of Rail

CANTON AREA RAILROADS

D1452190

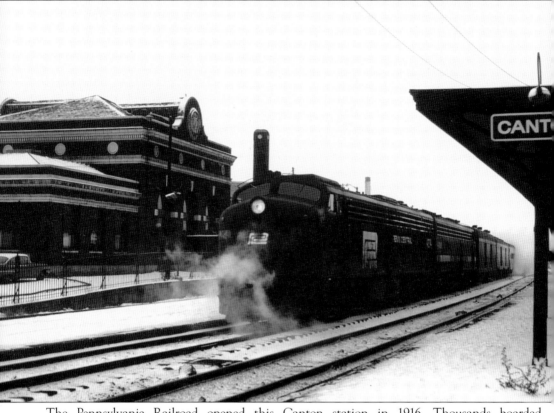

The Pennsylvania Railroad opened this Canton station in 1916. Thousands boarded Pennsylvania Railroad, Penn Central Transportation Company, and Amtrak trains at this depot before it was razed in October 1976. The westbound *Pennsylvania Limited* pauses at Canton on December 23, 1969, led by E8A No. 4294. With passenger service to Canton in a downward spiral, Penn Central had removed ticket agents and checked baggage service by the early 1970s. (Photograph by John Beach.)

On the cover: Before the Brewster cutoff opened on August 1, 1909, Navarre was the epicenter of the Wheeling and Lake Erie Railway's "iron cross." Toledo and Cleveland division passenger trains were scheduled to arrive here simultaneously. During Wabash Railroad control, the Wheeling and Lake Erie had through car service to Pittsburgh, Chicago, and St. Louis. Shown is the start of a 1904 four-train meet at Navarre. (Courtesy of Special Collections, Cleveland State University Library.)

IMAGES
of Rail

CANTON AREA
RAILROADS

Craig Sanders

ARCADIA
PUBLISHING

Copyright © 2009 by Craig Sanders
ISBN 978-0-7385-6111-0

Published by Arcadia Publishing
Charleston SC, Chicago IL, Portsmouth NH, San Francisco CA

Printed in the United States of America

Library of Congress Catalog Card Number: 2008934542

For all general information contact Arcadia Publishing at:
Telephone 843-853-2070
Fax 843-853-0044
E-mail sales@arcadiapublishing.com
For customer service and orders:
Toll-Free 1-888-313-2665

Visit us on the Internet at www.arcadiapublishing.com

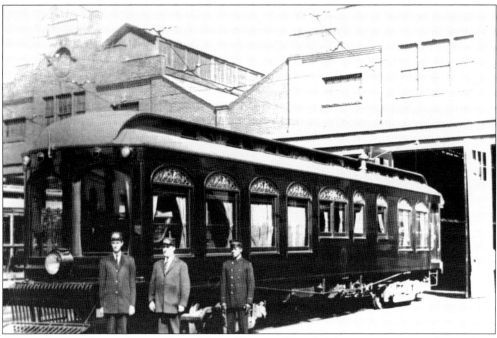

America's interurban railway era lasted about 50 years. Ohio led the nation in interurban railway mileage with almost 28,000 miles. Nearly every town with a population of at least 5,000 had service. Most of Ohio's interurban railway routes had been built by 1908 and nearly all were gone by 1939. Northern Ohio Traction and Light Company car No. 3 is shown at the Canton carbarns. (Courtesy of the Paul Vernier collection.)

CONTENTS

ACKNOWLEDGMENTS

The idea for this book came to me during a 2007 Labor Day weekend visit to Alliance to photograph trains of the Norfolk Southern Corporation, which now owns the tracks through town once used by the Pennsylvania Railroad. Alliance is one of the few places in Stark County that still sees a high volume of rail traffic. Although no town of any size in Stark County has lost rail service, far fewer trains today rumble through Canton or Massillon.

I expanded this book's scope to include the bordering counties because of the community of interest that they have with Canton and because the rail lines that served Stark County also served those places. The Canton region has a rich railroad history and still features a variety of railroad operations. Brewster, tucked away in the southwest corner of Stark County, remains the quintessential railroad town as the operating headquarters of the Wheeling and Lake Erie Railway. This book examines how railroads developed in the Canton region and how they got to where they are today.

In writing this book, I relied upon the expertise of several people, many of them members of the Akron Railroad Club. I would like to thank those who provided photographs: Richard Antibus, John Beach, Michael Boss, Peter Bowler, Jeff Darbee, Dan Davidson, Richard Jacobs, Jerry Jordak, Chris Lantz, James McMullen, Jeff Pletcher, Bob Redmond, Edward Ribinskas, Marty Surdyk, and Paul Vernier. A special thanks goes to the staffs of the Special Collections at the Cleveland State University Library and the Stark County Public Library for their assistance in helping me find photographs and historical information, and to Ed McHugh for providing historical information about Stark County railroad operations.

I also would like to thank Melissa Basilone, my editor at Arcadia Publishing, and publisher John Pearson for their assistance. Finally, this book would not have been possible without the assistance of my wife, Mary Ann Whitley, who copyedited the manuscript and provided encouragement and support throughout. The responsibility for any errors or omissions lies solely with the author.

INTRODUCTION

Canton is located in the southwest corner of a great industrial triangle that stretches north through Akron to Cleveland, southeastward through Youngstown to Pittsburgh, and westward back to Canton. Steelmaking was the backbone of this region, but numerous other industries built plants there as well.

Founded in 1805 by Bezaleel Wells, Canton was the first community to be settled in Stark County and is the county seat. The city initially spurned canal and railroad developers. Cantonians did not want the Ohio and Erie Canal, which linked Cleveland and the Ohio River port of Marietta, because they feared that standing water would be a source of disease. They refused to pledge financial support to the Cleveland and Pittsburgh Railroad (C&P) because they believed the railroad would build through Canton anyway. Instead the C&P built 18 miles to the east, prompting the founding of Alliance on September 26, 1850.

Development of the C&P, Stark County's first railroad, proceeded in fits and starts. Chartered in 1836 as the Cleveland, Warren and Pittsburgh Railroad, the franchise lapsed due to inactivity. Revived in 1845 as the C&P, lack of financing delayed construction until 1848. The line opened between Cleveland and Freedom (now part of Alliance) on July 4, 1851, and was completed in 1852 between Cleveland and Wellsville.

The following year, the State of Pennsylvania permitted the C&P to build in the Keystone State. On March 4, 1852, the C&P opened an extension to Rochester, Pennsylvania, where it connected with the Ohio and Pennsylvania Railroad (O&P). The two railroads jointly operated between there and Pittsburgh. The C&P's Tuscarawas branch, built through the Sandy Creek valley, opened between Bayard and New Philadelphia via Minerva and Dover on December 4, 1854.

Under prodding from Akron interests, the Ohio legislature had amended the C&P's charter to direct the company to build between Hudson and a connection with the O&P somewhere between Massillon and Wooster. The Akron branch opened between Akron and Hudson on July 4, 1852. Construction continued southward, reaching the O&P at Orrville in 1854. The Akron branch was completed to Columbus on September 1, 1873, following a series of reorganizations and ownership and name changes.

Canton's first railroad, the O&P, was chartered on February 24, 1848, in Ohio and on April 11 in Pennsylvania with authority to build between Allegheny City (annexed by Pittsburgh in 1907) and Ohio's western border. Construction began on July 4, 1849, and the first segment opened between Allegheny City and New Brighton, Pennsylvania, on July 30, 1851. The first Ohio segment was completed on November 27, 1851, between Alliance and Salem. Tracklaying crews working eastward from Alliance and westward from Pittsburgh met 61 miles east of Pittsburgh on January 6, 1852.

The last rail of the O&P between Pittsburgh and Massillon was laid on February 29, 1852. Two days later, the first railroad locomotive to puff into Canton, the *Allegheny*, arrived at 3:00 p.m. amid much curiosity. A dedication train that left Pittsburgh at 8:00 a.m. on March 11 officially opened the line. It reached Canton at 2:15 p.m., and passengers were treated with a dinner. The firing of ordnance greeted the train's arrival in Massillon, where railroad officials were feted at a banquet.

The O&P extended its tracks to Wooster on August 10, 1852, reached Mansfield on April 8, 1853, and opened to Crestline three days later. A bridge across the Allegheny River at

Pittsburgh opened on September 22, 1857, enabling the O&P to connect with the Pennsylvania Railroad (PRR).

The O&P never built west of Crestline. Instead the Ohio and Indiana Railroad opened between Crestline and Fort Wayne, Indiana, on November 1, 1854. The State of Indiana chartered the Fort Wayne and Chicago Railroad on May 11, 1852, to build between its namesake cities, but financial troubles stymied completion. The O&P, the Ohio and Indiana, and the Fort Wayne and Chicago merged on July 26, 1856, to form the Pittsburgh, Fort Wayne and Chicago Rail Road (CFtW&C), more commonly known as the Fort Wayne Line route. It completed the Pittsburgh–Chicago route, which opened on December 25, 1858.

The PRR, which had helped finance the bridge in Pittsburgh and operated through trains from Philadelphia over the Fort Wayne Line, leased the CFtW&C on July 1, 1869, transferring it in 1871 to a subsidiary, the Pennsylvania Company. The PRR leased the C&P on December 1, 1871. Although under the control of the Pennsylvania Company since January 1, 1912, the Akron branch was long known as the Cleveland, Akron and Columbus Railway, the name it assumed on December 31, 1885.

The Massillon and Cleveland Railroad (M&C) was incorporated on October 3, 1868, to build between Clinton (Warwick) and Massillon. The 12-mile line is thought to have opened on May 22, 1869, although it was not accepted from the contractor until June 22. That same day the Fort Wayne Line leased the M&C.

The Lake Shore and Tuscarawas Valley Railroad was formed on July 2, 1870, to build between Lorain and Wheeling, West Virginia. It opened on August 18, 1873, between Lorain and Urichsville, passing through Clinton, Massillon, Dover, and New Philadelphia. Forced into receivership after failing to pay its debts, it emerged on February 5, 1875, as the Cleveland, Tuscarawas Valley and Wheeling Railroad and reached Wheeling in 1880. Two years later, the company was back in receivership, emerging in March 1883 as the Cleveland, Lorain and Wheeling Railroad (CL&W). The Baltimore and Ohio Railroad (B&O) began operating the CL&W in 1909.

Envious that Massillon and Alliance had rail connections to Cleveland, a group of Canton residents chartered the Akron and Canton Railroad, which began construction in February 1873 but soon halted due to an economic downturn. The Valley Railway, incorporated on August 21, 1871, to build from Cleveland southward, was suffering a similar fate. Construction resumed in 1878, and the Valley was completed between Cleveland and Akron on October 28, 1878. Some 2,000 Canton residents turned out on September 24, 1879, when Valley tracklaying crews arrived. They were treated to a picnic dinner featuring 6 turkeys, 48 chickens, 60 pies, 300 sandwiches, 300 pounds of grapes, 30 gallons of coffee, and 8 kegs of beer.

Service between Cleveland and Canton did not begin until January 28, 1880. The fare was $1.75 one way or $2.75 for a round-trip ticket. The line opened to Mineral City on July 15, 1882. Rather than build to Wheeling, the Valley negotiated a trackage rights agreement, effective January 1, 1883, with the Wheeling and Lake Erie Railway (W&LE), with which it connected at Valley Junction.

The Valley entered receivership in 1894 and was reorganized on October 3, 1895, as the Cleveland, Terminal and Valley Railway (CT&V). The B&O had held a controlling interest in the Valley since January 1890 and began operating it in June 1909.

Canton's third railroad dates to the March 9, 1850, chartering of the Carroll County Railroad. It opened on May 24, 1853, between Carrollton and Oneida, where it connected with the C&P's Tuscarawas branch. The Carrollton road had been built with strap iron rails that only light locomotives could use. After its lone locomotive broke down in 1859, the company used mules to pull railcars until another locomotive was acquired and began operating on September 4, 1867.

Nicknamed the Elderberry Line due to a preponderance of elderberry bushes along the track, the railroad carried few passengers and hauled little freight. It was reorganized on February 26, 1866, as the Carrollton and Oneida Railroad.

E. R. Eckley, a Carrollton lawyer, Civil War general, and former congressman, formed the Ohio and Toledo Railroad on May 7, 1872, with the idea of building between Toledo and the Ohio River via Massillon. He purchased the Carrollton and Oneida on July 15, 1873, for $1, relaid the line with 32-pound iron T-rail, and opened an extension to Minerva on October 30, 1874. Eckley gave up building an east–west route in favor of expanding to Lake Erie.

The Ohio and Toledo went bankrupt and was acquired in 1878 by the narrow-gauge Youngstown and Connotton Valley Railroad (Y&CV), organized on August 29, 1877, to build between Bowerston and Youngstown. Instead the railroad built from Minerva Junction to Canton, arriving on May 15, 1880, to a gala celebration that included closing the schools and holding a parade to Public Square. The Y&CV opened an extension between Carrollton and Sherrodsville on January 1, 1882. Five months later, it shortened its name to the Connotton Valley Railway (CV).

The CV opened to Bedford in July 1881, with passengers completing the journey to Cleveland on C&P trains. The CV completed its own route into Cleveland in November, although passenger service did not begin until February 21, 1882. The CV opened a passenger station and headquarters at Tuscarawas Street East and Savannah Avenue in Canton in 1882. The depot featured a 96-foot-tall clock tower. The City of Canton also donated 46 acres of land on which the CV built locomotive and car shops.

The CV began pushing south of Canton in 1882, reaching Navarre on July 2, the same day as the W&LE. By December, the CV had been completed to Beach City. It reached Coschocton on June 11, 1883. Work began in September 1885 on a Zanesville extension that did not open until June 17, 1889.

The CV reorganized as the Cleveland, Canton and Southern Railroad (CC&S) on May 9, 1885. At 5:00 a.m. on November 18, 1888, a crew of 1,150 men converted the railroad to standard gauge.

The CC&S billed itself as the Tip-Top Route, but its finances were in anything but tip-top condition, particularly after many Cleveland industries switched from coal to oil to fire their furnaces and boilers. Track and equipment deteriorated, and by 1899, fewer than half of the company's 36 locomotives were operable.

The Waynesburg and Canton Railroad was built in 1884 between Waynesburg and a connection with the CC&S between Canton and Osnaburg (later East Canton). The CC&S acquired the nearly six-and-a-half-mile line on July 20, 1891, naming it the Marks branch. Its major feature was a short tunnel under an apple orchard.

Chartered on April 6, 1871, the W&LE was the brainchild of Joel Wood, a C&P ticket agent at Martins Ferry, Ohio, who saw an opportunity to tap Ohio coal deposits that the PRR was ignoring because it favored Pennsylvania coal mines.

Construction began in early 1872 but halted after a taxpayer filed suit to enjoin the city of Wheeling from giving the railroad a $300,000 grant. The financial panic of 1873, dissension among shareholders, and a dispute with the contractor building the railroad delayed the laying of the first rail until April 4, 1877.

The first W&LE train operated on May 31, 1877, on four miles of track near Norwalk. By late June, the railroad was operating over 12 miles between Huron and Norwalk and owned two locomotives. Most of its revenue came from Sunday passenger excursions, and the W&LE ceased operations in late 1879.

The moribund W&LE got a boost when financier Jay Gould, who envisioned it as a link between the Wabash Railroad and the Central Railroad of New Jersey, both of which he controlled, began buying W&LE securities. The W&LE began service between Huron and Massillon on January 9, 1882. That same year it reached Toledo on July 10 and Zoar Station—later renamed Valley Junction—in August. The W&LE negotiated trackage rights over the C&P line to Dover and began operating the Cleveland and Marietta Railway (C&M) in September 1882.

The latter had been organized on September 29, 1868, as the Marietta and Pittsburgh Railroad. Construction began in 1869 at Marietta with the intention of reaching Dennison. The company was renamed the Marietta, Pittsburgh and Cleveland Railway (MP&C) in December 1873, by

which time its intended terminus was Cleveland. It reached Dover in June 1874, using C&P trackage rights to access the city. Just over a year later, the MP&C was in receivership and emerged as the C&M. C&M shareholders in the spring of 1883 voted to end the relationship with the W&LE. The C&M continued to experience financial difficulties and the PRR later took control of it.

Fearing that the CV also intended to build to Wheeling, the W&LE pushed eastward, reaching Martins Ferry in November 1889. Service did not begin for another year. W&LE trains entered Wheeling via the Wheeling Bridge and Terminal Railway, which was completed in late 1890.

Like most railroads in southeastern Ohio, the fortunes of the W&LE rose and fell with coal. When the economy was good, the W&LE did not have enough cars to haul the coal needed to feed Midwest industries or enough crews to operate its trains. Accidents were commonplace and the W&LE became one of the most dangerous railroads in America. When the W&LE entered receivership on January 15, 1897, it marked the company's third trip to bankruptcy court.

George Gould, who had succeeded his father as head of the Gould railroad empire, purchased the W&LE and the CC&S at a foreclosure sale in February 1899. The W&LE absorbed the CC&S on August 14, 1899. Initially the two railroads were not a good fit. The W&LE already had a Cleveland entrance through its 99-year pact with the CT&V. Furthermore, the W&LE lacked the financial resources to rebuild the CC&S. The W&LE canceled the alliance with the CT&V, and the B&O obtained a controlling interest in the Valley in 1890 to gain access to Cleveland area industries.

The Steubenville and Indiana Railroad (S&I) was chartered on February 24, 1848, to build between Steubenville and an undetermined point on the Ohio-Indiana border between Willshire and Fort Recovery. The charter was amended a year later to provide for a branch between Coshocton and Columbus via Newark or Mount Vernon and the construction of a bridge across the Ohio River.

Construction did not begin until late 1851 and was beset by labor unrest and financial problems. The PRR helped underwrite the cost of building the S&I and it opened between Steubenville and Newark on April 11, 1855, serving the Tuscarawas County communities of Dennison, Urichsville, and Newcomerstown. Although the S&I had examined a Newark–Columbus route, it would build no farther west. With funding provided by the Columbus and Xenia Railroad, the S&I built a connection at Newark to the Central Ohio Railroad, later owned by the B&O, which operated to Columbus. The connection opened on April 16, 1867. The S&I purchased a half interest in the Newark–Columbus route in 1864, but a court in 1882 gave the B&O responsibility for operations and maintenance of the route.

A long-anticipated route between Steubenville and Pittsburgh across the West Virginia panhandle opened on October 9, 1865. The S&I merged on December 27, 1868, with the PRR-controlled Pittsburgh, Cincinnati and St. Louis Railway, known as the Panhandle. Mergers and acquisitions of various railroads in Ohio, Indiana, and Illinois enabled the PRR to create an unbroken Pittsburgh–St. Louis route via Columbus and Indianapolis in 1870, as well as routes to Cincinnati and Chicago via the Panhandle. The PRR also combined the former Cleveland and Marietta line with the Tuscarawas branch of the former C&P.

The PRR opened a bypass route between Fairhope Tower east of Canton and Bayard in November 1926. Heavy westbound freight trains used this 14-mile, double-track route to avoid steep grades on the Fort Wayne Line.

The Lake Erie, Alliance and Wheeling Railroad (LEA&W) was incorporated in 1874 to build between Alliance and Phalanx, where it connected with the Erie Railroad. Completed in 1877, the company entered receivership the next year and eventually became the Cleveland, Youngstown and Pittsburgh Railway, which extended the line southward to Bergholz. A series of reorganizations and sales over the next several years resulted in the property emerging on January 25, 1901, under its original name. A year later, the line was extended to Dillonvale. The Lake Shore and Michigan Southern Railway, controlled by the New York Central System, acquired LEA&W capital stock on January 1, 1903, and leased it on July 1, 1912.

One

ELECTRIC RAILWAYS

When 19th-century Canton residents talked about the horsepower of the Canton Street Railway, which began service on December 18, 1884, they did not mean the motors propelling the cars. Canton's streetcar system began with horse-drawn cars traveling four routes radiating from Public Square. A fifth route began on June 13, 1885, when the Lakeside Street Railroad began service to Meyers Lake.

The city of Alliance approved a franchise for the Alliance Street Railway on July 31, 1888. The system began with horsecars but had given way to electrified operation four months later in early 1889. Streetcar service started in 1888 in Dover and New Philadelphia.

Canton's streetcar system electrified in January 1890 and converted from a four-foot gauge to standard gauge in 1901. By then interurban railway building was blossoming in northeast Ohio. Canton's first interurban railway, the Canton and Massillon Electric Railway, began service on July 2, 1892, between its namesake cities.

The Stark Electric Railroad formed in 1902, soon purchased the Alliance streetcar company, and began Canton–Alliance service on May 1, 1903. A one-way trip took 40 minutes and cost 35¢. Service was extended to Beloit on January 11, 1904, and to Salem on August 19, 1904.

The Canton-Akron Railway (CAR), formed on April 4, 1901, began Canton–Akron service on May 16, 1902, connecting in Akron with Northern Ohio Traction and Light Company (NOTL). NOTL once had had its own plans to establish Akron–Canton service.

Service between Dover and Urichsville, and Massillon and Navarre, had begun in 1896, and the gap between Navarre and New Philadelphia was bridged in August 1902. In 1906, the CAR acquired all the interurban railways in Stark and Tuscarawas Counties except the Stark Electric. Consequently, the Canton-Akron Consolidated Railway merged with NOTL on October 1, 1906. NOTL extended the Massillon–Brookfield branch, which had opened in 1904, to East Greenfield in western Stark County in December 1907.

The last interurban company to build in Stark County was the Cleveland, Alliance and Mahoning Valley Railway (CA&MV), which began Alliance–Ravenna service on January 2, 1913. The CA&MV merged with NOTL on April 1, 1924.

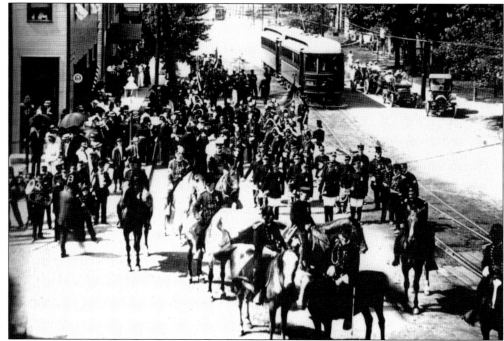

NOTL opposed the plans of the CAR to establish Canton–Akron interurban railway service, saying NOTL had the authority to serve the two cities. But the Canton City Council, on June 4, 1901, awarded the CAR a franchise and NOTL dropped its plans to establish Akron–Canton service. Canton-bound cars are shown at New Berlin (later North Canton) on Independence Day 1910. (Courtesy of the Paul Vernier collection.)

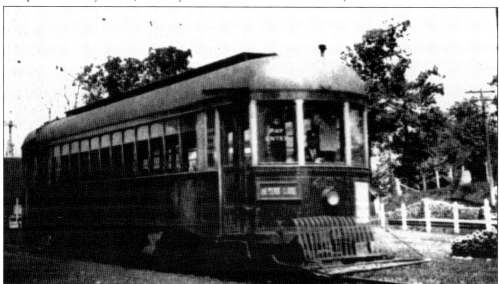

NOTL founded Canton's Meyers Lake amusement park. The Pennsylvania Railroad (PRR) operated excursion trains to Canton with park-bound patrons coming from as far away as Pittsburgh. During peak periods, NOTL cars ran to the park every three minutes. An NOTL car is shown at Meyers Lake, which was sold in 1922 to the Sinclair family and continued to operate long after streetcar service had ended. (Courtesy of the Paul Vernier collection.)

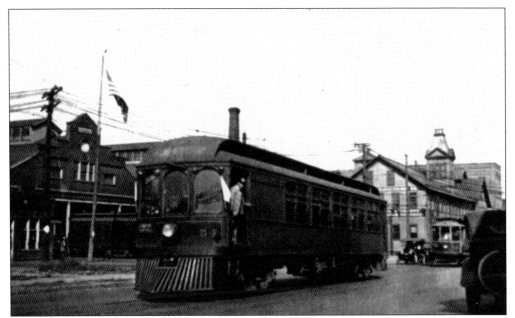

William H. Hoover, owner of a North Canton saddle leather company and best known for making vacuum cleaners, and Charles A. Kolp incorporated the CAR on April 4, 1901. Construction began in June but was delayed several months over a payment dispute regarding filling a quicksand sinkhole. Car No. 54, built in 1902 for the CAR, is shown at the Canton carbarn. (Courtesy of the Paul Vernier collection.)

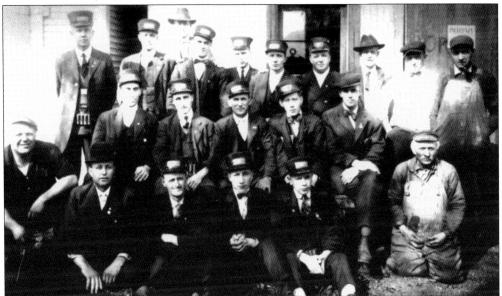

Interurban railways, with their lower fares and higher frequency of service, provided tough competition for steam railroads for short-distance travel. Interurban cars would stop at almost any crossroads in the countryside, thus providing rural residents a degree of mobility they had never had. Aside from providing transportation, interurban railways also employed thousands, including these NOTL workers shown in an undated photograph. (Courtesy of the Paul Vernier collection.)

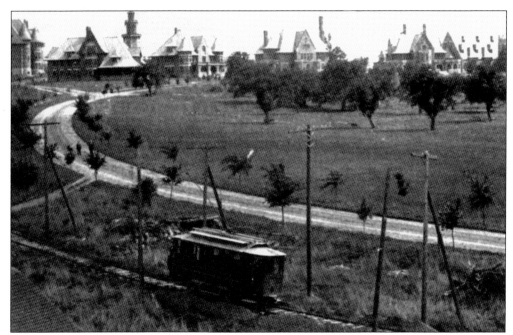

Massillon State Hospital was the largest of Ohio's 20 mental health institutions. Organized on March 31, 1892, it accepted its first patients on September 6, 1898. Located on the interurban railway line to Urichsville, the hospital also was served by Massillon city cars, one of which is shown here. Interurban service between Massillon and Urichsville operated for the last time on May 31, 1929. (Courtesy of the Paul Vernier collection.)

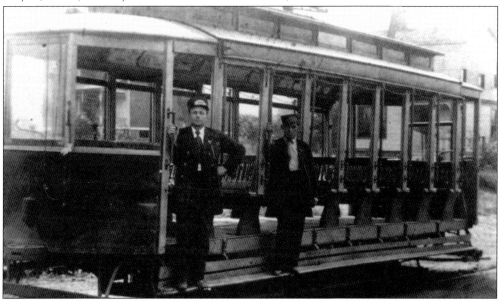

The CAR had 15 miles of city lines in Canton and Massillon. Buses began siphoning away riders in 1918, and eight bus lines operated in the Canton area by 1924. Massillon streetcar service operated for the final time on June 2, 1929, but Canton–Massillon interurban cars made local stops on routes they had shared with streetcars. Massillon car No. 481 is shown in 1911. (Courtesy of the Paul Vernier collection.)

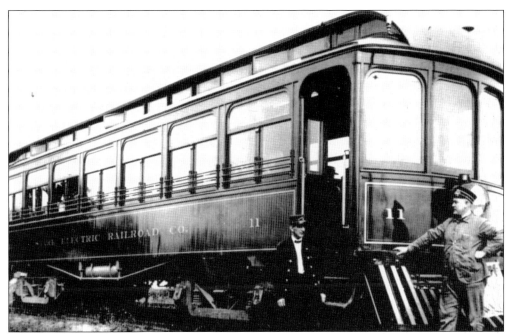

The Stark Electric Railroad linked Canton and Salem via Louisville, Alliance, Sebring, Damascus, and Beloit. It advertised 24-hour service and a $1 day pass that allowed unlimited travel. During daytime hours, the Stark Electric operated two round-trips an hour between Canton and Salem and four round-trips an hour between Canton (shown below) and Alliance. The Stark Electric was nicknamed "the bachelor railroad" because a majority of its founding directors were single and remained so while with the company. Headquartered in Alliance, unlike most Ohio interurban railways, the Stark Electric enjoyed growing patronage in the 1920s, peaking in 1929. When the Stark Electric operated for the final time on July 16, 1939, there were just 150 miles of interurban railways left in Ohio. (Above, courtesy of the Paul Vernier collection; below, courtesy of Special Collections, Cleveland State University Library.)

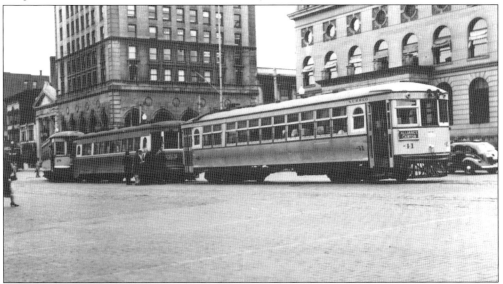

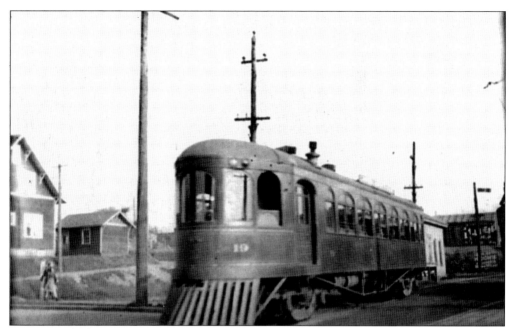

Not all interurban railway cars had a boxy appearance. Car No. 19 of the Stark Electric Railroad featured a more streamlined appearance. Built by the Jewett Car Company in 1914, No. 19 was involved in a head-on collision with car No. 20 on July 4, 1918. Parts of the Stark Electric right-of-way have been preserved as the Stark Electric Trail. (Courtesy of Paul Vernier collection.)

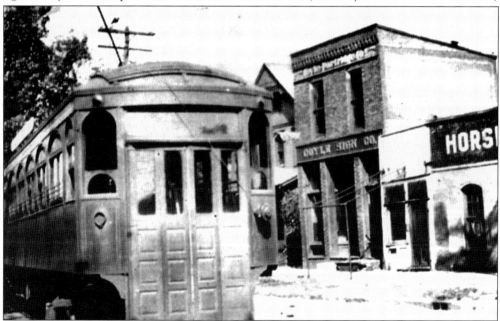

Car No. 8 of the Stark Electric Railroad sported what appears to be an unusual front door entrance, which may have been an experiment. In February 1907, Canton councilman Garion Naftger called for the city to enforce an ordinance limiting speeds of streetcars, which he described as shooting down hills "like a buck that had been shot from the rear." (Courtesy of the Paul Vernier collection.)

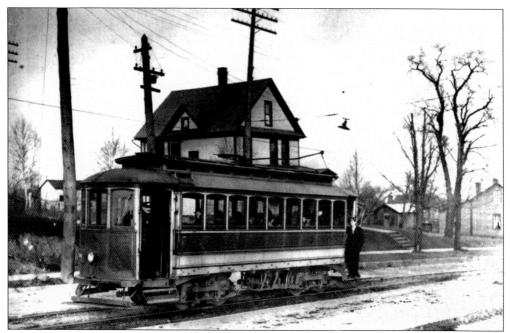

NOTL became Northern Ohio Power and Light Company (NOPL) in 1926. It said the Canton city lines were losing money and would be abandoned. After the Canton City Council objected, NOPL allowed the city to sell the rail in the streets for scrap. Canton streetcar service operated for the final time on April 18, 1931. Canton Motor Coach Company expanded service on abandoned streetcar lines. (Courtesy of the Paul Vernier collection.)

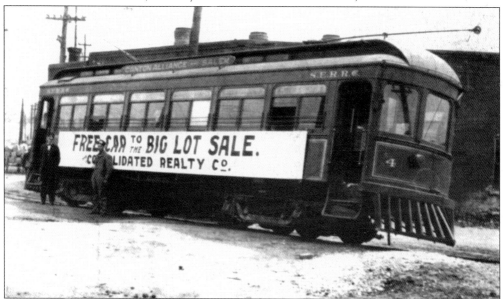

Electric railways played a major role in the migration of people from the centers of cities to undeveloped areas on the outskirts. Many middle-class workers held jobs in or near the city center, thus streetcars enabled them to commute to work. Stark Electric car No. 4, shown at Sebring, was built in 1895 by the Jackson and Sharpe Company and scrapped in 1913. (Courtesy of the Paul Vernier collection.)

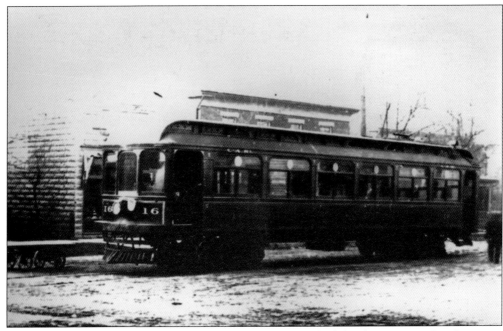

CAR car No. 16, shown at the Navarre station in 1906, was built by the St. Louis Car Company in 1902. Akron–Canton interurban railway service last operated on April 15, 1928. Its discontinuance cut the NOPL system in half. This probably hastened the demise of the southern end, which already had the smallest patronage in the system due to low population density. (Courtesy of the Paul Vernier collection.)

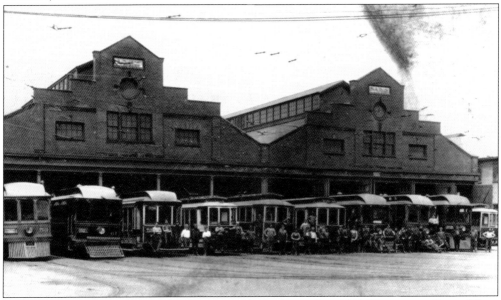

The Canton Street Railway stabled horses at barns located at 1501 Tuscarawas Street West. Electric-powered cars were maintained at facilities built on this site. Fire ravished the carbarns on October 3, 1893, destroying most of the equipment of the Canton city lines and much of the Canton–Massillon interurban fleet. NOTL workers pose with various cars in an undated photograph at the rebuilt barns. (Courtesy of the Paul Vernier collection.)

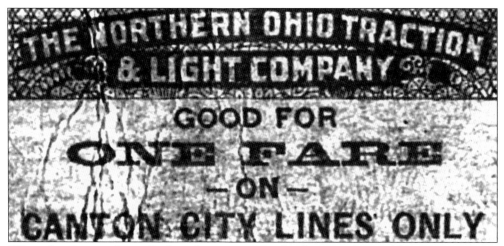

Working Card

Division No. 702

Located at Canton

h. C. Swartz

Dues 1.00 For Month of _____ 191__

Special Assm't _____ Local Sec., M. G. Holl

◆ 25

W. D. Mahon Int. Pres.

Many NOTL workers were members of the Amalgamated Association of Street and Electrical Railway Employees of America. Shown is a union membership card. When workers struck on May 2, 1926, the company hired strikebreakers in Akron and Canton. Service was largely restored 20 days later. The strike eventually was settled, but the union had suffered a setback. (Courtesy of the Paul Vernier collection.)

THE NORTHERN OHIO TRACTION & LIGHT COMPANY

GOOD FOR ONE FARE —ON— CANTON CITY LINES ONLY

When the Canton Street Railway began in 1884 the fare was 5¢ payable in coin. Patrons placed fares into a box with drivers carrying up to $2 in change. Drivers would ring a bell when a patron boarded and failed to pay the fare. Later NOTL sold paper tickets such as the one shown here. Canton's first streetcars were yellow with seating for 18. (Courtesy of the Paul Vernier collection.)

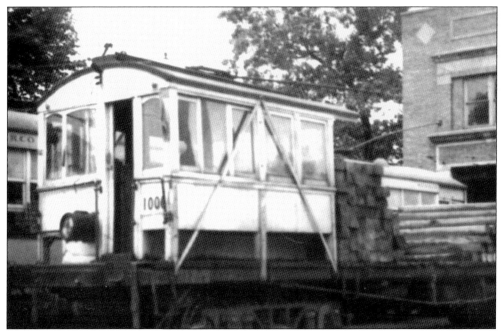

Line car No. 1006, used for maintenance chores, belonged to Inter-City Rapid Transit, which provided service between Canton and Massillon. Historian William Middleton described interurban railways as a transitional technology occupying a period when local travel was severely proscribed by the limitations of country roads, horse-drawn conveyance, and steam railroads, and the arrival of the almost universal mobility afforded by the automobile and improved roads. (Courtesy of the Paul Vernier collection.)

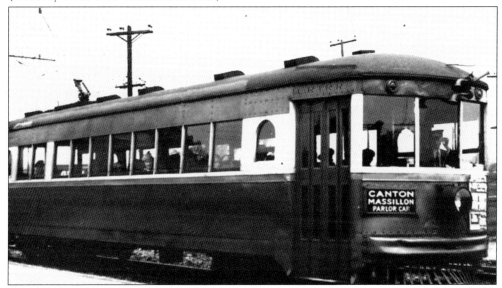

The Canton–Massillon interurban route, sold to Inter-City Rapid Transit on May 8, 1931, was Stark County's last electric railway. It operated in scheduled service for the final time on December 16, 1940. The Canton–Massillon route had been the oldest segment of the NOTL system, having operated for 48 years. The last car, chartered by former NOTL employees, reached the Massillon barns on December 17. (Courtesy of the Paul Vernier collection.)

Two

PENNSYLVANIA RAILROAD

The PRR was the nation's largest railroad in revenue and freight volume. In an industry where bankruptcies were common, the PRR never entered receivership and paid dividends to shareholders for more than 100 years.

Chartered in 1846 to establish a network of railroads and canals between Philadelphia and Pittsburgh, PRR invested heavily in connecting railroads and would eventually lease or control more than 800 railroad companies. Its 10,000-mile web of routes spanned between New York and Washington, and Chicago and St. Louis, generally north of the Ohio River.

In 1916, the PRR adopted the slogan "the Standard Railroad of the World." Not only did the PRR view itself as the railroad to which others aspired, it implemented standardized plans for locomotives, rolling stock, signaling systems, and stations.

By the 1950s, the mighty PRR was in trouble. Trucks had siphoned away freight, while passengers increasingly favored air travel or their own vehicles. The PRR had to contend with enormous passenger deficits, high taxes, transportation policies favoring highway and airway development, intransigent labor unions, and government regulators loath to permit abandonment of lightly used passenger trains and branch lines.

Eastern railroads believed that consolidation was the ticket to better times, and on November 1, 1957, the PRR and New York Central System announced that they were studying a merger. "No two railroads in the country [are] in a better position . . . by reason of their location, duplicate facilities and services, and similarity of traffic patterns, to consolidate their operations and at the same time substantially increase efficiency and provide an improvement in service at lower cost," said PRR chief executive James Symes.

It took more than 10 years to consummate the merger, which moved through the Interstate Commerce Commission and the courts with the speed of a coal drag grinding upgrade. New York Central head Alfred Perlman was never enthusiastic about the merger—he described it as a takeover—but could never arrange the marriages with other railroads that he desired. The Pennsylvania New York Central Transportation Company came to life shortly after midnight on February 1, 1968.

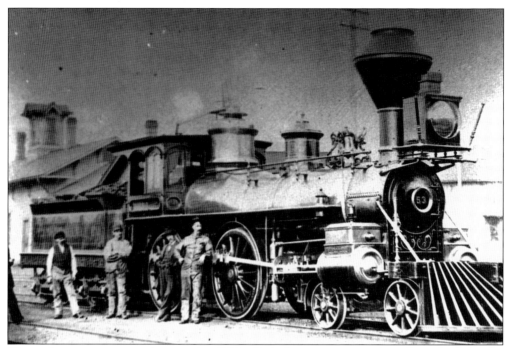

These photographs were taken in the 1880s. Both locomotives may have been built by the PRR because of their similarity to PRR-built 4-4-0 steam engines for passenger and freight service. The PRR designed most of its steam locomotives and built many of them in its Altoona Machine Shop (1866–1904) and Juniata Shops (1891–1946) in Altoona, Pennsylvania. The Altoona Machine Shop built approximately 2,289 locomotives whereas the Juniata Shops built 4,584 engines before ceasing steam locomotive construction in June 1949. Many of these locomotives continued in service on other rail lines after being retired by the PRR. The locomotive in the photograph below is lettered for the Pittsburgh, Cincinnati, Chicago and St. Louis Railway, a PRR subsidiary that was better known as the Panhandle because its Pittsburgh–Columbus route crossed the panhandle of West Virginia. (Courtesy of the Michael Boss collection.)

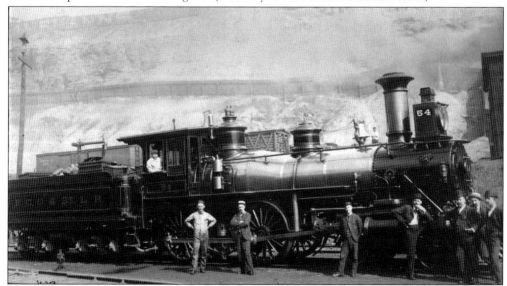

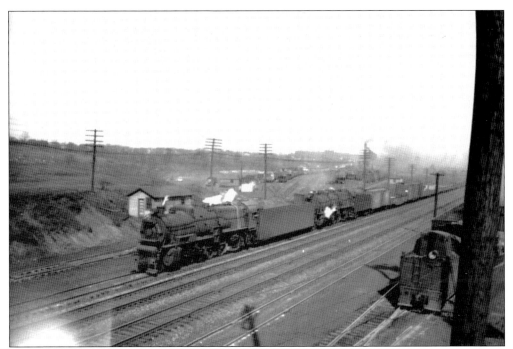

The PRR was accustomed to doing things in its own way and described itself as the standard railroad of America. The PRR might design and build a fleet of locomotives only to scrap them all because the operating department was displeased with their performance. A manifest freight is shown passing the Canton yards behind doubled-headed steam locomotives during the late 1940s. (Photograph by Bob Redmond.)

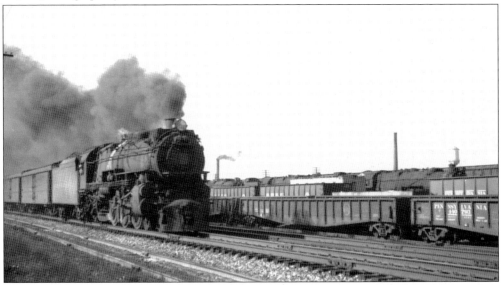

The K4-class Pacific-type locomotive was the PRR's primary locomotive power assigned to passenger trains. Between 1914 and 1928, the PRR built 351 of these 4-6-4 locomotives at its Altoona shops with another 75 built by Baldwin Locomotive Works in Philadelphia. Their ubiquitous nature led to them being labeled "America's most famous Pacific." A K4 is shown pulling a train past the Canton yards. (Photograph by Bob Redmond.)

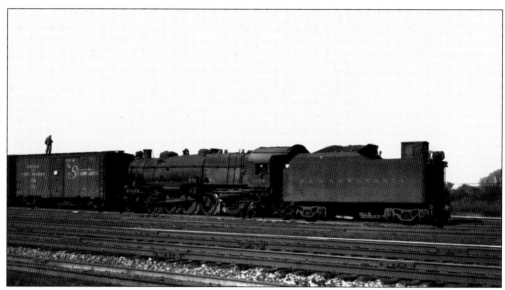

The Canton yard collected freight cars from area industries, served as the base for helper locomotives operating between Canton and Pittsburgh's Conway Yard, and was home base for several local freight jobs that worked east of Canton and in the city itself. L1-class Mikado-type No. 1368 shuffles cars in the yard in October 1949. The PRR built 574 of these 2-8-2 locomotives between 1914 and 1919. (Photograph by Bob Redmond.)

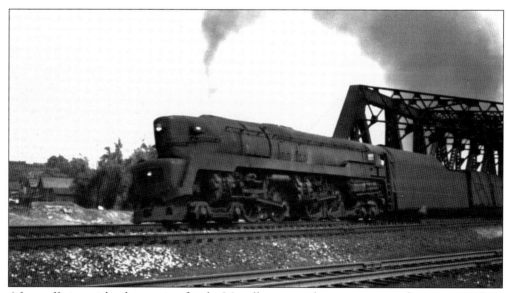

After suffering eight destructive floods, Massillon created a conservancy district in 1939 to straighten the Tuscarawas River, build new levees, and relocate railroads to reduce the number of grade crossings. The PRR constructed a bridge over the Tuscarawas River that is one of the few of its kind built on a curve. A PRR T-1 steam locomotive crosses the bridge shortly after it opened in 1948. (Photograph by Bob Redmond.)

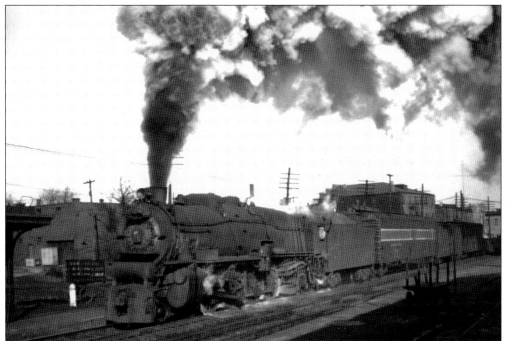

The PRR did not embrace diesel locomotive power as quickly as most of its peers. In part this was because hauling coal accounted for a significant share of the PRR's freight revenue. By the early 1950s, when this photograph of a westbound manifest freight entering Orrville was recorded, the question was no longer if steam would remain the railroad's primary motive power, but for how long. (Photograph by Bob Redmond.)

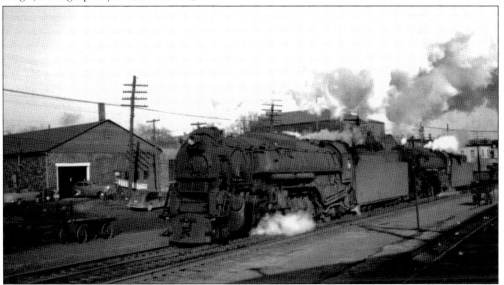

Orrville, located 22 miles west of Canton, had a small yard and a tower that controlled the crossing with the PRR's Hudson–Columbus line. Just west of Orrville, trains tackled a 1.1 percent climb up the east side of the Wooster hill, the steepest westbound grade between Rochester, Pennsylvania, near Pittsburgh, and Crestline. Perhaps that is why this manifest freight has two burly locomotives in charge. (Photograph by Bob Redmond.)

Organizations catering to railroad enthusiasts emerged in the 1920s. The largest was the National Railway Historical Society (NRHS), founded in 1935 in Philadelphia. In June 1937, several Akron men created the Eastern Ohio Chapter of the NRHS. The chapter sponsored several excursions until World War II halted excursion trains. Following the war, differences of opinion about purpose and direction led to a split. Akron area members formed the Akron Railroad Club while members living in the Canton-Massillon area favored retaining the NRHS affiliation. In April 1946, they organized the Midwest chapter, which became quite active in sponsoring steam train excursions. In the photograph above, a Midwest chapter excursion on the PRR is shown at Bayard in July 1948. In the photograph below, the train is at a tunnel between Magnolia and Mineral City on the Tuscarawas branch. (Photographs by Bob Redmond.)

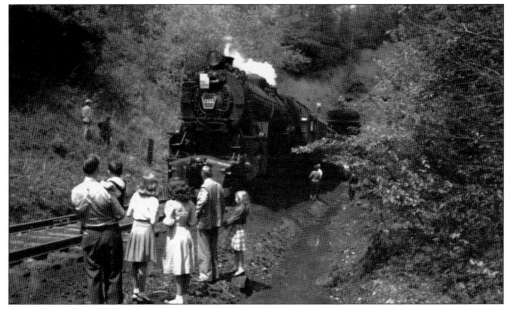

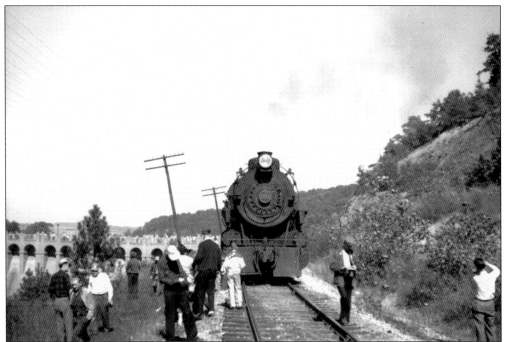

Scheduled passenger service on the PRR's Tuscarawas branch ended between Bayard and Zoarville in 1930, and was discontinued south of Valley Junction three years later. In the photograph above, an excursion train pauses in September 1949 at Dover Dam on the Tuscarawas River, three miles southeast of Dover. The dam, completed November 29, 1937, is used for flood control. In the photograph below, a July 1948 excursion train has stopped at Valley Junction, where the PRR crossed the Toledo-Wheeling of the Wheeling and Lake Erie Railway, later the Nickel Plate Road (NKP). The Tuscarawas branch between Dover and Pekin (four miles southwest of Minerva) was not conveyed to Conrail and was abandoned in 1976. Much of the track between Pekin and Minerva was abandoned in July 1982. The State of Ohio owns the track between Minerva and Bayard. (Photographs by Bob Redmond.)

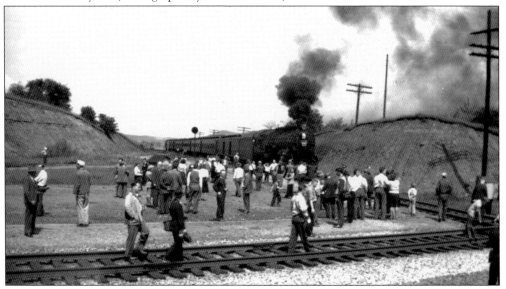

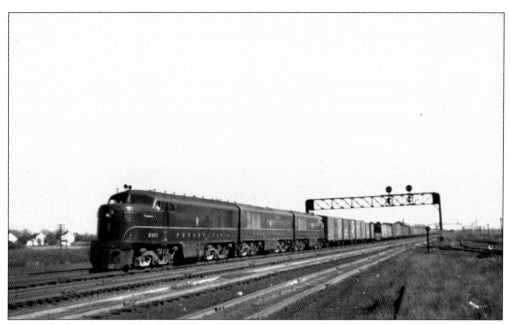

With a high volume of freight and passenger traffic, the Fort Wayne Line (Pittsburgh, Fort Wayne and Chicago Rail Road) between Pittsburgh and Crestline featured some sections of three- and four-track main line. There were three tracks between Alliance and Fairhope Tower in Canton and between Smithville and Big Run Tower west of Wooster and four tracks between Fairhope Tower and Reed Tower in Reedurban (between Canton and Massillon). Much of the Fort Wayne Line was governed by automatic block signals with signals set up for single-direction operation on each track. In the photograph above, a manifest freight led by Fairbanks-Morse FF-20-class No. 9461 passes westward at Fairhope in May 1955. In the photograph below, a manifest freight is coming off the Bayard cutoff in a 1962 view taken from a Fairhope Tower window. (Above, photograph by Bob Redmond; below, photograph by John Beach.)

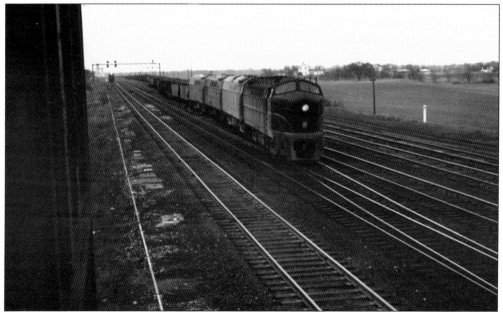

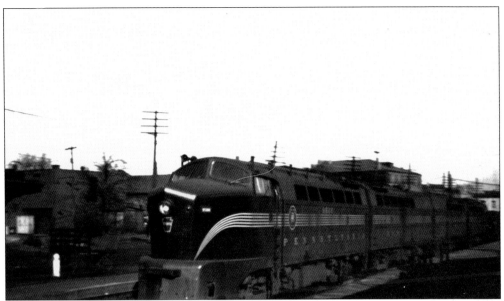

Although the PRR bought its first diesel locomotives in 1937, steam remained the primary locomotive power through the late 1940s. Beginning in 1947, the PRR began buying diesel locomotives in large numbers after completing a study of the economics of diesel versus steam power. Initially the PRR purchased diesel locomotives from nearly every manufacturer. Early PRR diesels featured a handsome pinstripe and keystone livery as shown in the photograph above of a westbound train at Orrville about to diverge from the Fort Wayne Line to the Columbus line or into the yard. Later the PRR simplified the pinstripes into a single stripe as shown in the photograph below of No. 9535, an F3A built by the Electro-Motive Division of the General Motors Corporation in 1948, leading a manifest freight in the Canton yard in October 1949. (Photographs by Bob Redmond.)

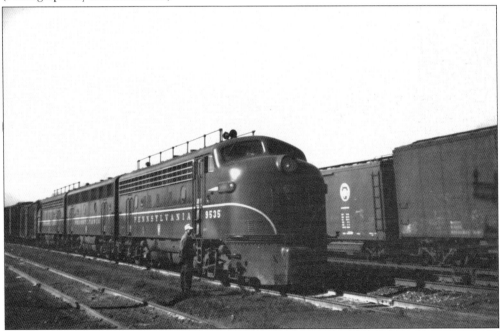

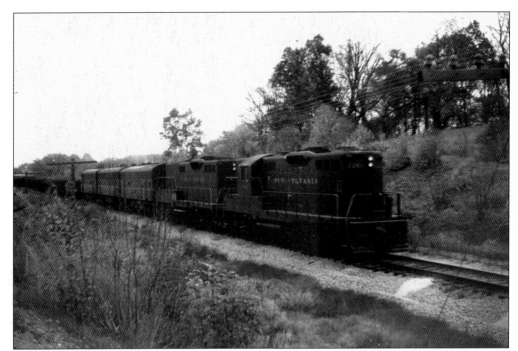

Bayard was the junction of the Tuscarawas branch, the line to the Ohio River via Yellow Creek and the Bayard cutoff to Canton. The river line hosted ore trains that originated at the Lake Erie docks at Cleveland and fed the many steel mills in the Ohio River valley. An eclectic collection of locomotives is shown hauling an ore train at Bayard in October 1966. (Photograph by John Beach.)

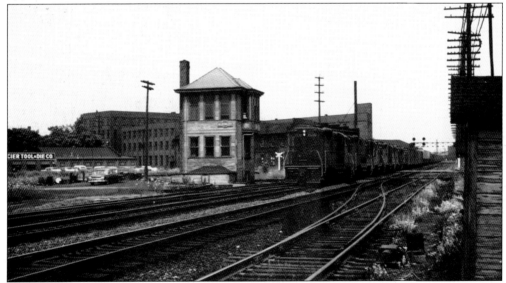

With the end of steam motive power in sight, the PRR decided in 1956 to order a massive fleet of GP9 locomotives from the Electro-Motive Division, much to the displeasure of Baldwin Locomotive Works, which had built locomotives for the PRR for several decades. A string of six "geeps" leads a westbound manifest freight at McKinley Tower in Canton in 1960. (Photograph by John Beach.)

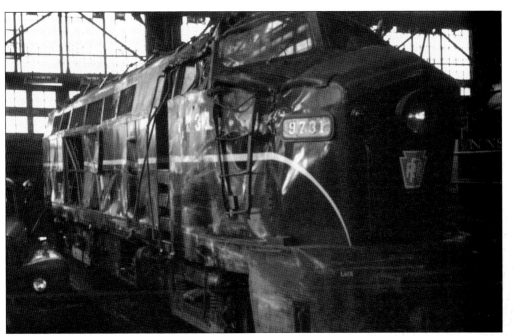

The PRR bought 643 diesels from Baldwin, which was about 10 percent of the diesels that the company built. Baldwins were dubbed "shark noses" for their distinctive fronts. No. 9731, an RF-16-class locomotive built in February 1951, has been brought to the Canton shops on March 9, 1963, to repair damage incurred in a derailment. Conrail would later use these shops to repair maintenance of way equipment. (Photograph by John Beach.)

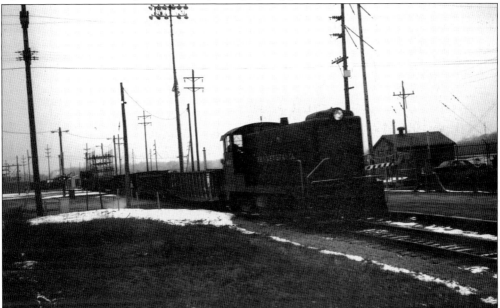

With the steel plants of Republic Steel and the Timken Company to serve, the PRR stationed a fleet of switch engines in Canton. Diverging from the main line in Canton and Massillon were a series of branches that reached the steel companies and other freight customers. A PRR Baldwin switch engine is shown moving a cut of cars in Canton in 1966. (Photograph by John Beach.)

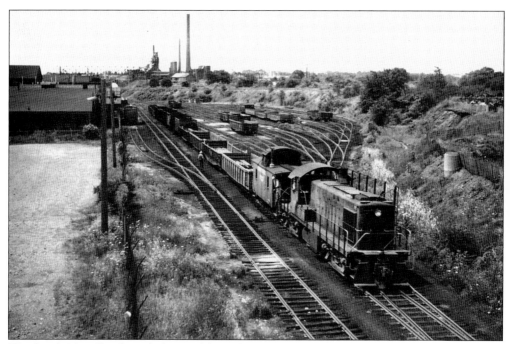

The South Massillon branch diverged from the Fort Wayne Line just south of Mace Tower. The PRR maintained this yard to serve a Republic Steel facility that can be seen in the distance. An RS-1 built by the American Locomotive Company is shown working the yard in July 1960. Although the South Massillon branch still exists, neither it nor the South Massillon yard were active in 2008. (Photograph by John Beach.)

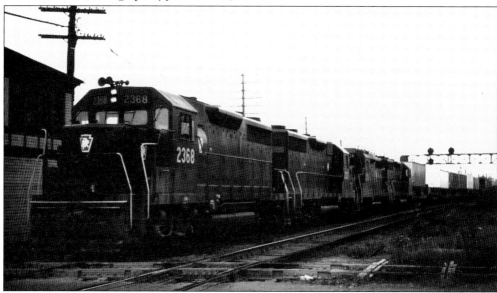

Wall Tower in Alliance controlled the crossing of the PRR's Fort Wayne Line with the Alliance branch of the New York Central System. The tower closed in February 1972 after the Alliance branch had been abandoned and the crossing removed. The tower subsequently was razed. A westbound trailer train crosses the junction at Wall on August 14, 1966, with GP35 No. 2368 in the lead. (Photograph by James McMullen.)

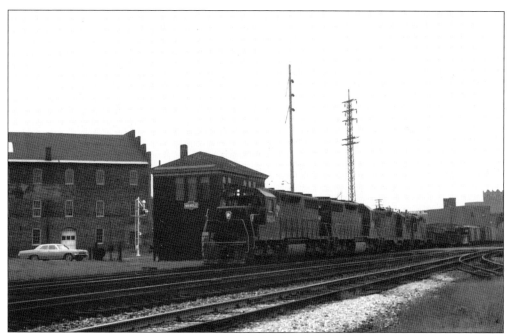

The PRR main line crossed the W&LE (later the NKP) in downtown Canton at Wandle Tower. The tower name derived from Wheeling and Lake Erie, combing the first letters and the word *and*. Wandle was one of three interlocking towers maintained by the PRR in Canton in the 1960s. A westbound PRR manifest freight passes by Wandle Tower in September 1965, led by SD35 No. 6034. (Photograph by James McMullen.)

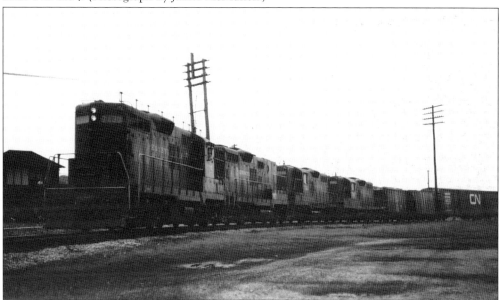

Most traffic on the Hudson–Columbus line was north of Orrville. Trains between Cleveland and western points joined or exited the Fort Wayne Line at Orrville. Flooding washed out the Columbus line north of Holmesville on July 4, 1969, and the damaged track was never rebuilt. A Cleveland-bound train is on the connection from the Fort Wayne Line at Orrville on August 14, 1966. (Photograph by James McMullen.)

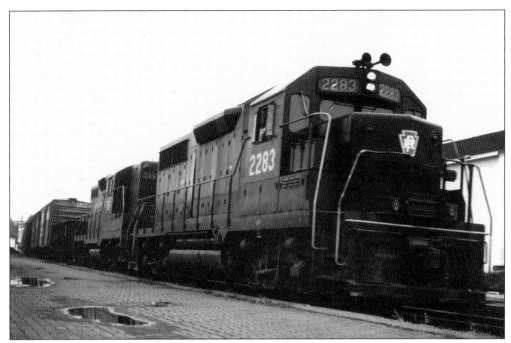

The Hudson–Columbus line was the PRR's only direct Cleveland–Columbus route but had a meandering path that included a 1.25 percent grade at Baddow Pass. Much of the freight on the line's daily Columbus-bound manifest freight was automotive parts from Twinsburg and Bedford bound for assembly plants in St. Louis or the Southwest. Penn Central Transportation Company favored the superior former New York Central System route between Cleveland and Columbus, and the PRR route was abandoned between Orrville and Holmesville in 1972. Service to Holmesville ended in 1979 after a state subsidy expired. In the photograph above, GP35 No. 2283 leads a westbound train at Orrville on August 14, 1966. In the photograph below, No. 9850, an FP7A, leads an eastbound train in a view captured on June 20, 1965, at Orrville from the W&LE bridge. (Photographs by James McMullen.)

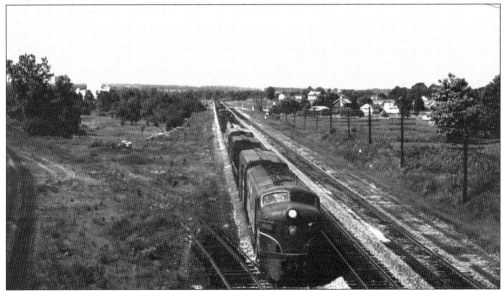

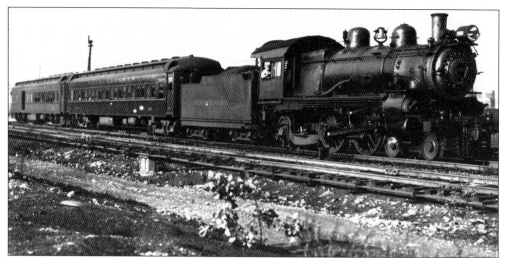

No. 253 and No. 254 were Alliance–Cleveland commuter trains that operated through October 23, 1959. By then the trains originated in Pittsburgh and made just one stop—Ravenna—between Alliance and Hudson. These were the last Cleveland-line passenger trains to serve Alliance until the coming of Amtrak's *Capitol Limited* on November 11, 1990. No. 253 is shown on June 28, 1935. (Courtesy of Special Collections, Cleveland State University Library.)

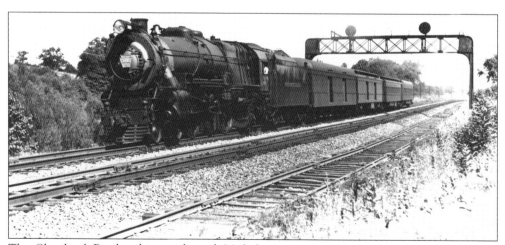

The Cleveland–Pittsburgh route hosted 36 daily passenger trains in the early 1940s, but by March 1957, service between the two cities had fallen to three round-trip pairings: the *Morning Steeler* and *Afternoon Steeler* (both via Alliance) and the *Clevelander* (via Youngstown). Within two years all the *Steelers* were gone. The last passenger trains between Cleveland and Pittsburgh operated on January 29, 1965. (Courtesy of Special Collections, Cleveland State University Library.)

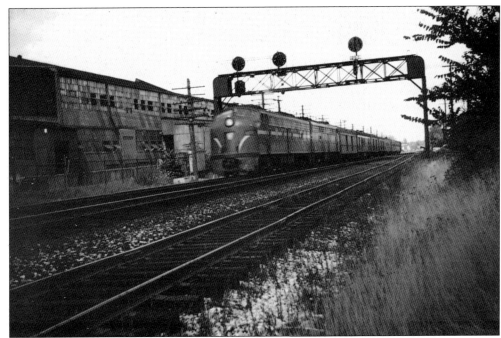

During World War II, the PRR served nearly half the nation's population and operated about 15 percent of its passenger train fleet. In late 1944, 39 scheduled passenger trains passed through Canton, excluding extra sections. By the early 1950s, the PRR had begun consolidating trains in an effort to reduce a burgeoning passenger deficit. The westbound *Fort Pitt* passes through Canton in August 1960. (Photograph by John Beach.)

Dating to the late 1880s, the *Pennsylvania Limited* was once a premier passenger train but was downgraded to a local in April 1956. By the middle 1960s, it had an 18-hour schedule between Chicago and New York and stopped at many smaller stations in Ohio and Pennsylvania. Westbound No. 55, still sporting a sleeper and diner-lounge, passes through Orrville on June 20, 1965. (Photograph by James McMullen.)

By early 1957, the PRR operated 18 passenger trains through Canton, most of which arrived between 6:00 p.m. and 8:00 the next morning. The December 13, 1967, consolidation of the *Broadway Limited* and *General* reduced service to eight trains. In early 1968, the PRR passenger fleet through Canton included the *Pennsylvania Limited*, *Broadway Limited*, *Manhattan Limited*, the eastbound-only *Admiral* (all of which operated between Chicago and New York), and the *Fort Pitt*, a Pittsburgh-to-Chicago train shown above changing crews at Canton on August 14, 1966. Scheduled to depart at 2:00 p.m., the *Fort Pitt* was one of Canton's few daytime passenger trains. The eastbound *Fort Pitt* had ended by February 14, 1960. In the photograph below, the Canton platform is clear as the *Fort Pitt* awaits a highball command. (Photographs by James McMullen.)

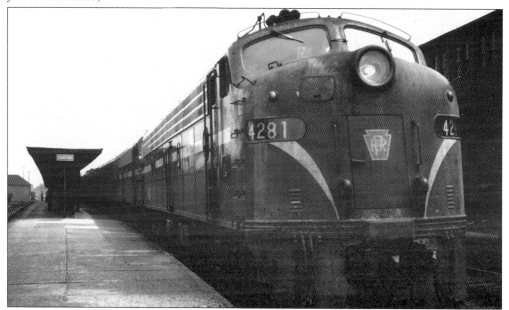

THE PULLMAN COMPANY
PASSENGER'S CHECK——To identify
accommodations purchased.

Office 13-46

628

Canton to North Philadelphia, Pa.

Upper
Berth No._____ CAR_____

Line No._____ Via_____ R.R

No. Persons 1 2

FORM 7

The amount charged is The Pullman
Company's rate and a **SURCHARGE OF
50% OF THAT AMOUNT REQUIRED BY
AND COLLECTED AS AGENT FOR THE
RAILROAD COMPANY, as follows:**

Pullman Company retains • • $2 40
Railroad Company receives • • 1.20
 Total Charge - • $3.60

Property taken into car will be entirely
at owner's risk.

Canton was Ohio's largest city on the Chicago–Pittsburgh main line, but many PRR trains did not receive passengers there because they reached Canton in the dead of night. In the early 20th century, the PRR labeled its premier trains the Blue Ribbon Fleet. After acquiring new equipment in the 1930s, these trains became the Fleet of Modernism. Shown is a May 14, 1926, Pullman ticket. (Courtesy of the Paul Vernier collection.)

Inaugurated on June 15, 1902, as the *Pennsylvania Special*, the all-Pullman Chicago–New York *Broadway Limited* was not just the PRR's flagship train, it was one of the best trains in America. Until December 13, 1967, the *Broadway* did not handle passengers at Canton. A late westbound *Broadway Limited* is shown at Mansfield on July 30, 1967, with observation car *Mountain View* bringing up the rear. (Photograph by James McMullen.)

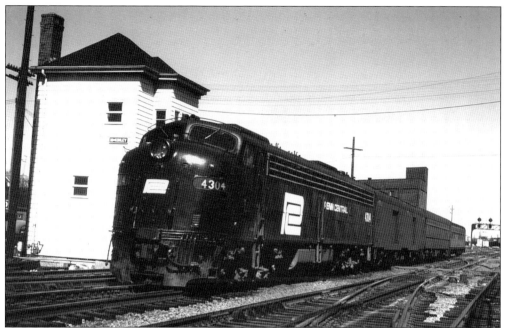

Penn Central made little pretense of its disdain for passenger trains. On March 3, 1968, it removed sleepers from the *Manhattan Limited* and westbound *Pennsylvania Limited*, diverted bulk mail to freight trains, and ended the Washington sleepers and coaches of the *Broadway Limited*. Penn Central wanted to end the *Fort Pitt* and *Admiral*, which had been profitable until losing mail and express traffic, but the Interstate Commerce Commission thwarted the discontinuances. In 1968, Penn Central trains on the former PRR averaged 382 passengers a day through Pittsburgh, of which more than 100 rode the *Broadway Limited*. Other trains each averaged 40 patrons. The lackluster ridership is reflected in the dearth of coaches assigned to the *Fort Pitt*, shown above in Canton on April 5, 1970, and below at the Massillon station on November 8, 1970. (Photographs by John Beach.)

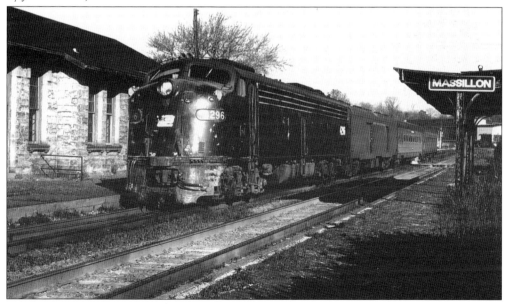

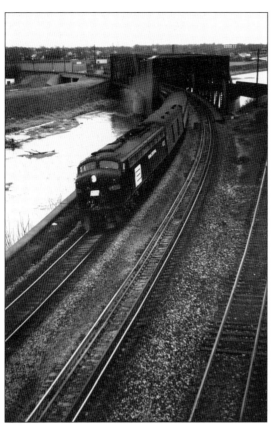

On March 10, 1970, Penn Central announced it would discontinue 34 passenger trains, including all trains serving Canton, claiming a loss of $8.9 million on 1969 revenue of $22 million. The Interstate Commerce Commission figured the losses at closer to $5.7 million. A court order kept all trains operating until the coming of Amtrak. The *Fort Pitt* is shown at Massillon on Christmas Day 1970. (Photograph by John Beach.)

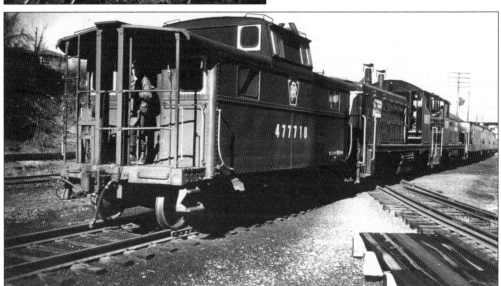

Rolling stock painted in the livery of the PRR or New York Central System lasted for several years into the Penn Central era. A former PRR cabin car "leads" a train on the South Massillon branch in April 1971. The train is crossing the track used by the Norfolk and Western Railway (N&W) and Baltimore and Ohio Railroad (B&O) to cross the Tuscarawas River to reach customers near downtown Massillon. (Photograph by John Beach.)

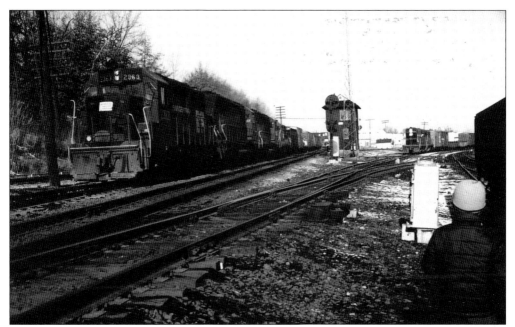

An eastbound Penn Central manifest freight train passes Mace Tower in Massillon in January 1972 behind GP35 No. 2363 while a Canton local waits for a signal at right. The local is on the line to Warwick, a junction with the former PRR's Hudson–Columbus line and the B&O's Chicago–Pittsburgh route via Akron. The boy at right is the photographer's 10-year-old son, Gary. (Photograph by Richard Jacobs.)

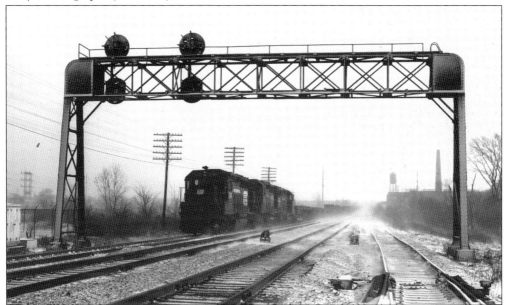

The PRR had a tower named Urban in Reedurban between Canton and Massillon at the end of four-track territory. After it closed, the railroad named the junction CP Reed. Four tracks are still in place at Reed as a Penn Central freight kicks up some snow on December 16, 1972. Penn Central locomotives had a simple livery of black paint and the interlocking *P* and *C* logo. (Photograph by John Beach.)

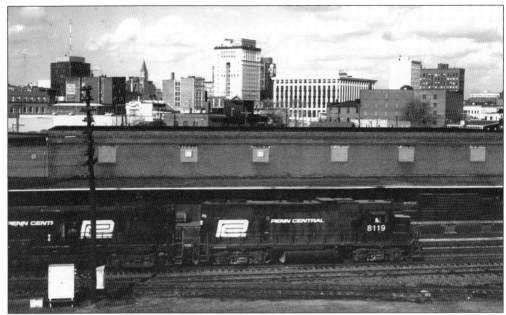

Penn Central became associated with poor tracks, slow trains, and lost freight cars, some of which sat on sidings for years before being "found." Some yard tracks were in such poor condition that trains derailed while standing still. An eastbound train led by GP38-2 No. 8119 passes near Cherry Street in Canton on November 20, 1976, as the city skyline looms in the background. (Photograph by John Beach.)

Not all the PRR's freight between Chicago and Pittsburgh traveled over the Fort Wayne Line. Some freight moved on the former Panhandle via Columbus; Bradford, Ohio; and Logansport, Indiana. Between Pittsburgh and Crestline, the Fort Wayne Line traversed numerous grades that required helper locomotives. A westbound Penn Central freight passes the yard at Orrville in February 1972, led by SD40 No. 6052. (Photograph by Richard Jacobs.)

A westbound Penn Central intermodal train passes the Wooster passenger station in August 1972. Train crews knew Wooster for a hill located east of town that featured a 1.1 percent grade westbound and a 0.88 percent grade eastbound. Heavy trains often needed helper locomotives to get over the hill. Passenger trains served this station through April 30, 1971, but Amtrak trains never stopped here. (Photograph by Jeff Darbee.)

The PRR's South Massillon branch passed over N&W and B&O tracks on this bridge. The three railroads alternated switching Republic Steel's South Massillon plant with the PRR handling the duties August through November. Penn Central No. 9174 and No. 9041, a pair of SW7 switch engines, are in charge of this train passing over the N&W and B&O on March 4, 1971. (Photograph by John Beach.)

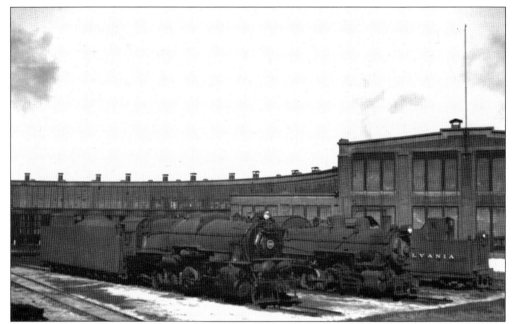

The Canton yards had an adjacent 30-stall roundhouse. Although busy in the steam era, the roundhouse began playing a lesser role after the PRR replaced steam locomotives with diesels in the 1950s. The last PRR steam locomotives dropped their fires in 1957. The Canton roundhouse, shown in 1948, was eventually razed, the turntable removed, and the turntable pit filled in with dirt. (Photograph by Bob Redmond.)

Located on Canton's east side, the PRR's yard was a series of yards, each serving a different purpose. One Yard and Eight Yard were, respectively, on the north and south sides of the main line tracks and received inbound trains. Five Yard, which had a hump, and Seven Yard were side by side and used for switching cars. The yard complex is shown on February 4, 1978. (Photograph by John Beach.)

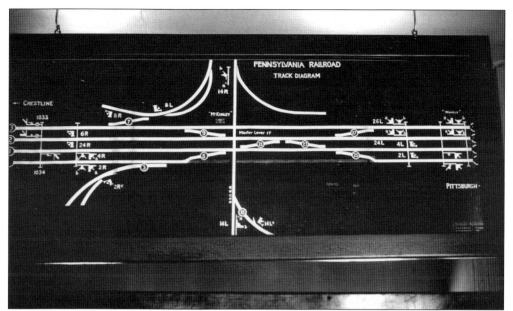

Interlocking towers controlled switches and signals at busy junctions. A model board displayed the track layout in the tower's territory. Shown above is the model board at McKinley Tower in Canton at the crossing of the PRR's Fort Wayne Line with the B&O's Cleveland–Valley Junction route. To assist operators in lining a route, the model board displayed numbers corresponding to which levers or handles to move to align a switch or set a signal. By the time this image was recorded on June 12, 1981, Conrail had removed one of its four tracks across the diamond with the B&O. In the photograph below, the operator records train movements on a log. The board above his head shows grade crossings. The scissors-style telephone was used to talk with the dispatcher and other tower operators. (Photographs by John Beach.)

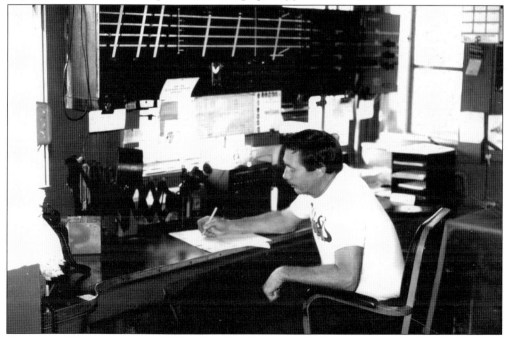

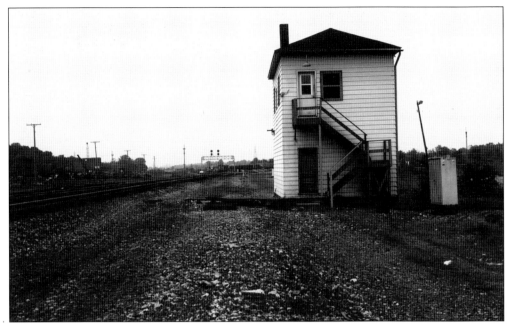

Fairhope Tower at the east edge of the Canton yard was the western terminus of the Bayard cutoff, a 14-mile double-track route opened in November 1926 as an alternate freight route between Rochester, Pennsylvania, and Canton. Although featuring lesser grades, neither Penn Central nor Conrail made extensive use of the cutoff, and it had been abandoned by 1983. The view is westward on June 7, 1984. (Photograph by John Beach.)

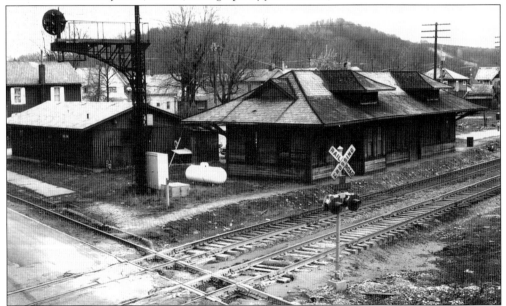

Newcomerstown was the junction of the PRR branch to Marietta with the Pittsburgh–Columbus main line. The latter had four passenger trains a day until the coming of Amtrak on April 30, 1971, although none of these trains served Newcomerstown. Thereafter the Columbus route hosted Amtrak's New York–Kansas City *National Limited* until its discontinuance on October 1, 1979. The view is from Town Tower. (Photograph by John Beach.)

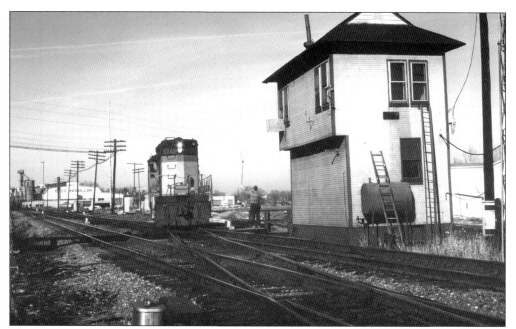

The junction of the PRR and B&O at Mace Tower in Massillon featured movable point switches rather than diamonds due to the sharp angle of the crossing. Mace was originally known as M&C Junction, after the Massillon and Cleveland Railroad, which terminated here. A Chessie System train is about to cross the junction as the tower operator prepares to hand up train orders. (Photograph by John Beach.)

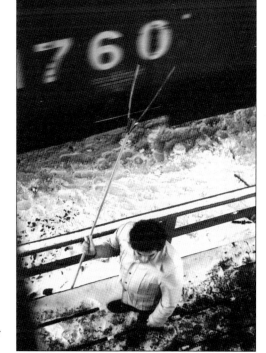

Tower operators often handed up train orders tied with string to a train order hoop. The orders were the dispatcher's instructions for meeting another train, going into a siding, or granting authority to operate against the current of traffic on track signaled in one direction. The operator at Mace Tower in Massillon has just given orders to a passing Conrail train in January 1977. (Photograph by John Beach.)

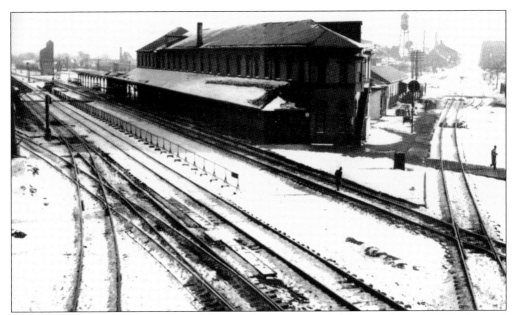

Opened in 1865, the station in the photograph above served Alliance through 1952. Situated at the junction of the Fort Wayne Line and the Cleveland line, nearly 50 scheduled passenger trains, excluding extra sections, passed through Alliance in 1944. Some Cleveland–Pittsburgh trains operated via Youngstown on B&O trackage rights. Trains originating in Alliance included Cleveland commuter trains and a Pittsburgh local. The track leading toward the upper right is the former C&P route to Wellsville. Passenger service on that route, a local to East Liverpool, last operated on November 15, 1947. After razing the Alliance depot, the PRR dedicated on February 23, 1953, the smaller station shown in the photograph below in 1964. It served as a passenger station until May 1, 1971. (Above, courtesy of the Paul Vernier collection; below, photograph by James McMullen.)

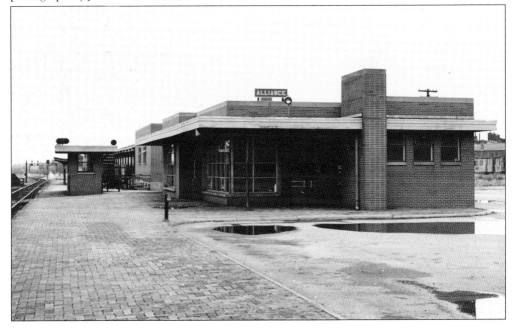

The PRR depot at Killbuck in Holmes County outlasted the railroad's Hudson–Columbus route. The last passenger trains here, Cleveland–Columbus No. 624 and No. 625, departed for the final time on December 14, 1950, on their overnight runs. The southbound train reached Columbus with 12 cars, two of them Pullmans carrying army inductees. Freight service ended between Holmesville and Howard in 1979 and between Howard and Columbus in 1981. (Photograph by Bob Redmond.)

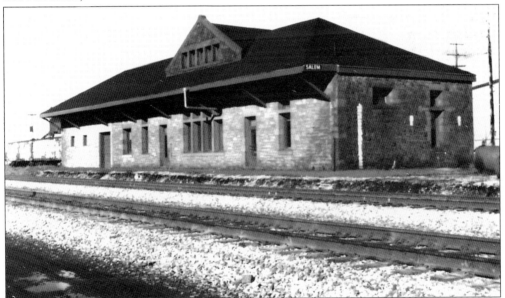

This stone passenger station in Salem on the Fort Wayne Line 14 miles east of Alliance was served by five daily passenger trains until the 1971 coming of Amtrak. Salem was the eastern terminus of the Stark Electric Railway and the last station on the Youngstown and Ohio River Railroad. The depot was razed after being heavily damaged in a July 31, 1997, Conrail derailment. (Photograph by Bob Redmond.)

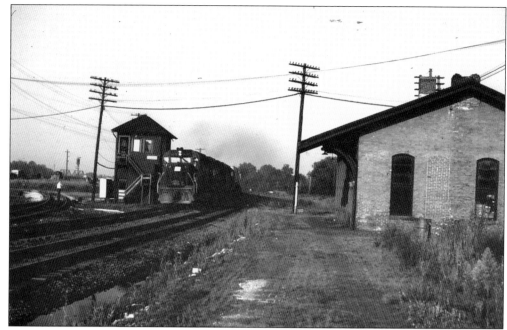

The Orrville Union Depot was built in 1868 by the Pittsburgh, Fort Wayne and Chicago Rail Road and also served the Cleveland, Akron and Columbus Railway, both of which later became part of the PRR. The station and block tower, located across the tracks from the depot, were purchased by the Orrville Railroad Heritage Society and restored. An eastbound Penn Central freight passes both on August 27, 1972. (Photograph by Jeff Darbee.)

Railroad-highway crossbucks once were made of iron and urged motorists to watch for approaching trains. Gates and flashing signals now protect many crossings. However, crossbucks with reflective metal blades mounted on wooden posts are still used today with a few crossbucks dating to the 1930s or before still serving as warning sentinels on lightly used lines. This old-style crossbuck was photographed on May 23, 1981, in Bayard. (Photograph by Jeff Pletcher.)

Three

CONRAIL

The PRR and New York Central System had been fierce competitors for decades, and that sense of rivalry could not easily be put aside. Their differences ranged from cultures to computer systems. Penn Central never achieved the economies it expected, and costs spiraled out of control. Deferred maintenance of track and rolling stock became rampant in the face of declining revenue. Questionable accounting methods masked the true extent of its financial troubles.

Penn Central entered bankruptcy proceedings on June 21, 1970. No railroad wanted to take over Penn Central wholesale and few supported a Penn Central management proposal to reorganize by shedding 45 percent of its track. Liquidation might cause irreparable harm to northeastern industries.

The federal government responded by adopting the Regional Rail Reorganization Act on January 2, 1974. The United States Railway Association drew up a reorganization plan for six bankrupt northeastern railroads that Congress approved in November 1975. The Railroad Revitalization and Regulatory Reform Act, signed by Pres. Gerald Ford on February 5, 1976, folded the bankrupt railroads into the Consolidated Rail Corporation, commonly known as Conrail, on April 1, 1976.

Armed with $2 billion in public money and unprecedented regulatory freedom, Conrail rebuilt track, acquired new equipment, and ditched scores of rail lines through abandonment or sale to other railroads. Conrail turned its first profit in 1981.

A fierce debate raged in Washington in the late 1980s whether to sell Conrail or allow it to continue an independent existence. Congress chose the latter with the Conrail Privatization Act of 1986, which Pres. Ronald Reagan signed on October 21, 1986. Conrail sold $1.9 billion in stock to investors on March 26, 1987.

During a wave of railroad consolidations in the 1990s, CSX Transportation reached an agreement to buy Conrail. Fearful of being overshadowed, Norfolk Southern Corporation (NS) triggered a bidding war that ended in spring 1997 with CSX and Norfolk Southern agreeing to divide Conrail. NS received 58 percent of Conrail's assets (about 6,000 route miles) while CSX received 42 percent of the assets (about 3,600 route miles). CSX and NS began operating Conrail on June 1, 1999.

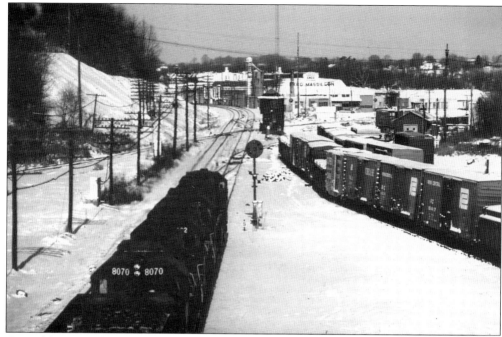

Conrail began with 17,000 route miles, 6,000 of which it did not want. The Fort Wayne Line between Pittsburgh and Crestline would be a key Conrail conduit for trains serving Columbus, Cincinnati, Indianapolis, and St. Louis, but tracks west of Crestline would be downgraded. That was in the future as a westbound train gets a clear signal at Mace Tower in Massillon on December 31, 1976. (Photograph by John Beach.)

In its early years, Conrail locomotives operated in the liveries of their predecessor companies. Heralds of predecessor railroads were painted over and the initials CR were substituted. In the case of former Erie Lackawanna Railway locomotives, shop crews merely had to paint out the EL initials and substitute Conrail initials. This former Erie Lackawanna locomotive was recorded on December 20, 1979, at Mingo Junction. (Photograph by Jeff Pletcher.)

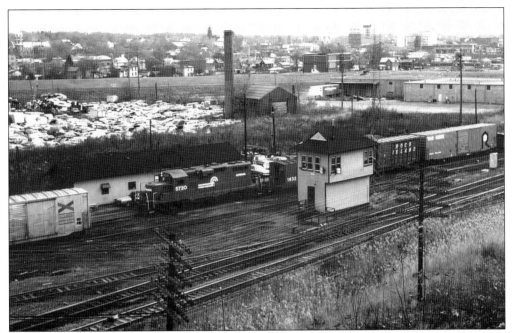

Conrail in 1977 launched a massive rebuilding of the Fort Wayne Line east of Crestline that included installation of centralized traffic control between Orrville and Alliance. This led to the closing between 1979 and May 1985 of numerous interlocking towers. Dispatchers in Pittsburgh now controlled signals and switches once lined by operators in such towers as Mace in Massillon, shown on November 19, 1977. (Photograph by John Beach.)

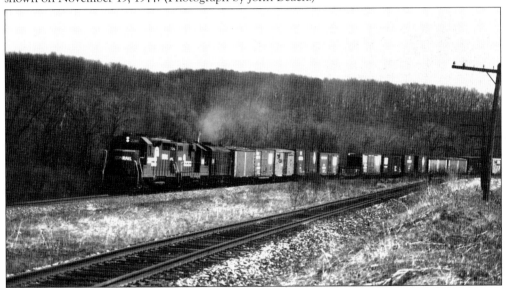

The PRR and B&O had parallel Clinton–Massillon routes and agreed on January 2, 1904, to a paired trackage arrangement. Northbound trains used the PRR while southbound trains used the B&O, which was responsible for dispatching both lines. The practice of trains between Cleveland, Akron, and Pittsburgh using this route ended after Conrail rebuilt the Cleveland–Pittsburgh route. A Conrail train is at Crystal Spring on April 9, 1977. (Photograph by John Beach.)

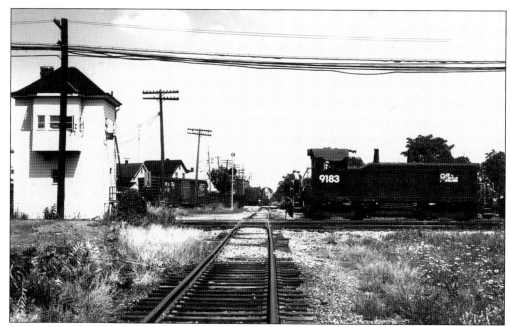

Conrail began with 4,886 locomotives that included 74 different diesel models built by four manufacturers. It took weeks, even months, for many locomotives to receive their new numbers and years before all had received Conrail's blue livery. A Conrail local approaches the crossing with the Chessie System at McKinley Tower in Canton on August 10, 1983, as a southbound Chessie train waits for clearance. (Photograph by John Beach.)

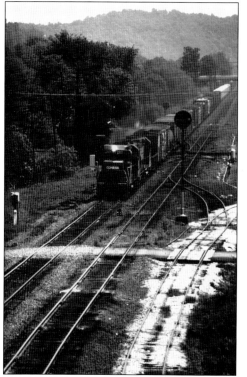

A new connection at Crestline linking the Fort Wayne Line with former New York Central System routes to Columbus and St. Louis changed traffic patterns on the former PRR's St. Louis route. Pittsburgh–Indianapolis trains began using the Crestline connection on March 6, 1982, while Pittsburgh–Columbus traffic followed suit in December. A Conrail train crosses the B&O at Urich Tower in Urichsville, on May 28, 1971. (Photograph by John Beach.)

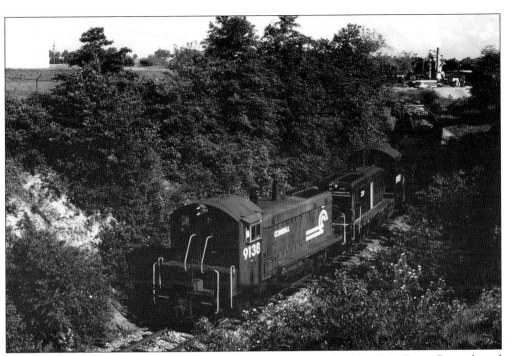

Canton's steel plants were a major source of freight business for the PRR, Penn Central, and Conrail. This business has diminished, but Conrail successor NS still does business in Canton with Republic Engineered Products (formerly Republic Steel) and the Timken Company. A Conrail local heads for the Timken roller bearing plant in Canton on June 10, 1982, using a branch that diverged near Maryland Avenue. (Photograph by John Beach.)

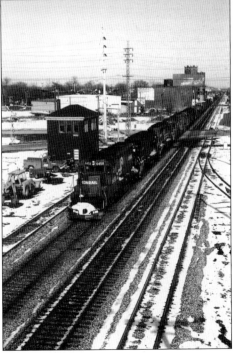

The photographer climbed a signal bridge to record this westbound Conrail manifest freight passing Wandle Tower in Canton on February 13, 1983, led by SD40-2 No. 6458. The track diverging to the right went to the Cherry Street yard where Conrail interchanged traffic with the Chessie System and N&W. The yard, Wandle Tower, and one of the four tracks in this view are now gone. (Photograph by John Beach.)

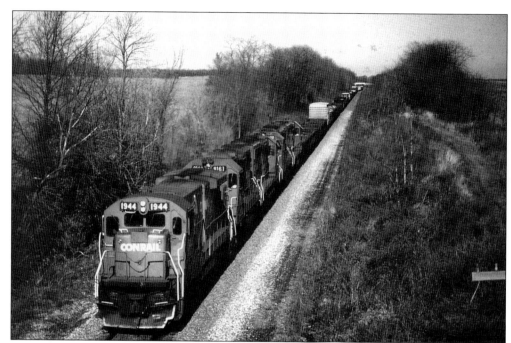

Although much of the traffic on the 13-mile stretch of the Cleveland line between Alliance and Bayard was coal and iron ore, Cleveland–Pittsburgh manifest freights that otherwise would travel the Fort Wayne Line sometimes used this route. Trains operated via Yellow Creek and rejoined the Fort Wayne Line at Rochester, Pennsylvania. B23-7 No. 1944 leads a Conrail manifest freight just south of Alliance in February 1992. (Photograph by Marty Surdyk.)

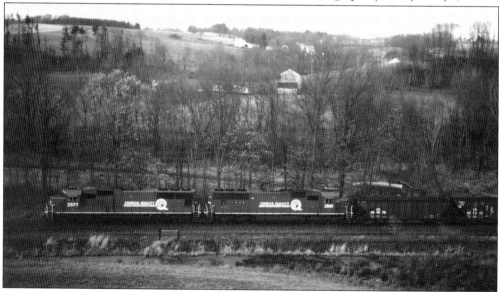

Iron ore unloaded from Great Lakes freighters at Cleveland used the single-track Bayard line south of Alliance to serve steel mills along the Ohio River. Conrail in 1997 replaced the 75-ton ore jennies once used by the PRR with 100-ton open hopper cars. A southbound ore train is passing through Moultrie in December 1996, led by SD70s No. 2577 and No. 2561, both built in 1998. (Photograph by Marty Surdyk.)

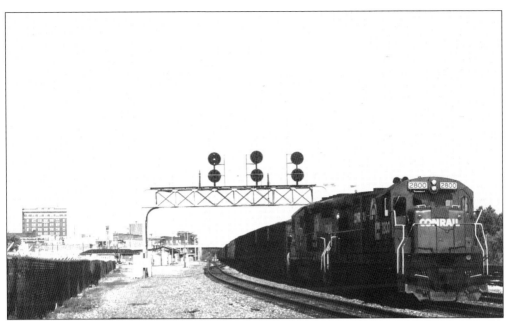

By the 1990s, Conrail was sending about 50 trains a day over the Cleveland line between Cleveland and Alliance. Much of this traffic was intermodal trains, but manifest freights, as well as coal and iron ore trains, were also part of the mix. An eastbound Conrail train passes the signal bridge just south of the Alliance station in August 1992, led by B23-7 No. 2800. (Photograph by Marty Surdyk.)

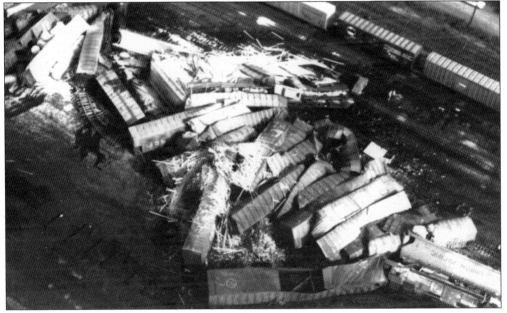

Four locomotives and 54 cars of an eastbound Conrail train derailed in the early morning hours in Alliance on September 12, 1979. Five crew members were treated for minor injuries. The 96-car train carried perishable commodities, lumber, and foodstuffs, but no hazardous materials. The photographer, Forrest Barber of the Alliance Police Department, is also a pilot and captured this image from a plane. (Courtesy of the Paul Vernier collection.)

The Fort Wayne Line hosted about 18 manifest and intermodal freight trains between Alliance and Crestline in the latter years of Conrail. Freight originating or terminating in or passing through the gateway cities of St. Louis, Indianapolis, Cincinnati, and Columbus used the Fort Wayne Line east of Crestline. An eastbound manifest freight passes through Alliance on the Fort Wayne Line in May 1997, led by SD40-2 No. 6518. (Photograph by Marty Surdyk.)

In Conrail's early years, the Fort Wayne Line hosted 50 freight trains a day between Orrville and Crestline and upward of 70 trains during peak shipping periods. However, traffic steadily fell as Conrail reduced what it termed excess capacity in Ohio and Indiana through line sales or abandonment. A westbound intermodal train passes beneath the W&LE bridge at Orrville in March 1999. (Photograph by Richard Jacobs.)

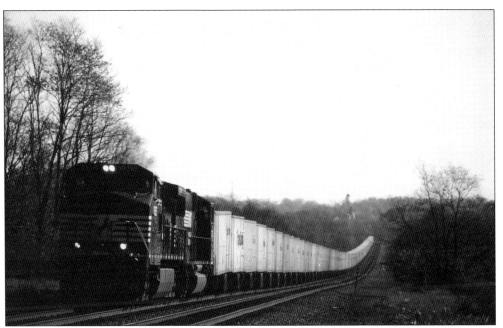

A RoadRailer is a truck trailer that can operate in a dedicated train. The Chesapeake and Ohio Railway (C&O) originated the concept in 1952. NS formed a subsidiary company, Triple Crown Service (TCS), in 1986 to provide RoadRailer service. Conrail purchased a half interest in TCS in 1993 and opened a RoadRailer terminal at Crestline. An NS RoadRailer is shown in the "Garfield sag" east of Alliance. (Photograph by Marty Surdyk.)

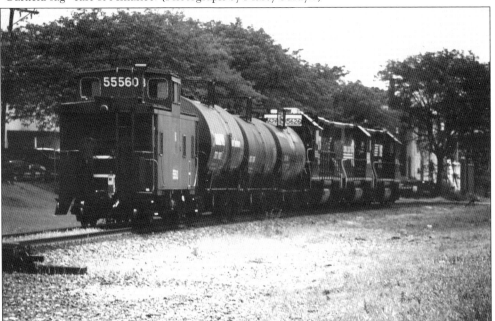

An NS local freight train is at Orrville on June 26, 2008, with tank cars bound for a J. M. Smucker Company plant there. Smucker's, which is headquartered in Orrville, is a food products company best known for its jellies and jams. The caboose is used to provide the conductor a safe place to stand while the train makes a back-up move. (Photograph by Craig Sanders.)

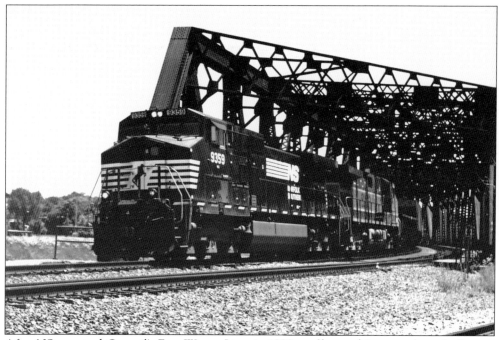

After NS acquired Conrail's Fort Wayne Line in 1999, traffic on this route through Canton greatly diminished. NS and CSX routed most of the freight that used to travel over this line in the Conrail era to new routings via Cleveland. Most NS Fort Wayne Line traffic, such as this train at Massillon in June 2008, travels between Pittsburgh and Columbus or Bellevue. (Photograph by Peter Bowler.)

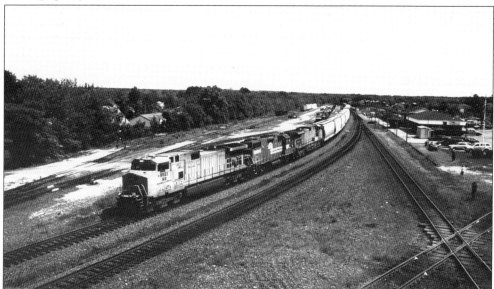

Conrail built a double-track connection in 1983 at Alliance between the Fort Wayne Line and Cleveland line, to help facilitate moving Pittsburgh–Chicago traffic to the former New York Central System route west of Cleveland. In 1998, Conrail expanded centralized traffic control on the Cleveland line and installed a cab signal system. A westbound NS train moves onto the Cleveland line at Alliance on August 28, 2005. (Photograph by Craig Sanders.)

Four

BALTIMORE AND OHIO RAILROAD

Hauling coal mined in the southeastern Ohio coalfields prompted the creation of the two B&O lines in the Canton-Massillon area, but for decades B&O trains also moved steel, chemicals, petroleum, rubber, agricultural products, iron ore, clay, lumber, and other goods. Passenger service on both lines was modest.

The former Valley Railway route through Canton hosted three round-trip passenger trains a day in the 1920s, one of which was a Cleveland–Marietta train operating on the PRR south of Valley Junction. Service to Marietta ended on July 18, 1933, but service to Valley Junction, using a diesel railcar, continued through September 30, 1934.

The C&O took control of the B&O on February 4, 1963, but each railroad retained its identity until June 15, 1973, when they began operating as the Chessie System. Chessie merged with Seaboard Coast Line Industries in September 1980 to form CSX Corporation. The B&O's corporate existence ended on April 30, 1987.

In October 1992, CSX sold the former Valley line between Canton and Sandyville to the W&LE. The W&LE leased the track from CSX between Canton and Aultman. CSX ceased providing freight service between Aultman and Akron in 1993.

Seeking to preserve the line for possible commuter train use, Akron Metro Regional Transit Authority purchased the route between Akron and Canton in May 2000. W&LE continues to provide freight service on the line.

The Cleveland, Wooster and Muskingum Valley Railway (CW&MV) was organized on October 1, 1880, but was not finished until 1895. The line diverged from the B&O's Chicago–Pittsburgh main line at Lodi and ran 36.26 miles south to Millersburg via Wooster. The B&O owned and operated the CW&MV.

The route was abandoned south of Wooster in 1928. The line north of Wooster was washed out in a July 1969 storm and Chessie trains began reaching Wooster via the former PRR west of Massillon.

R. J. Corman Railroad Group acquired the ex-B&O line between Clinton and Urichsville from CSX in December 1988. The route is abandoned south of Urichsville. In July 2002, Corman acquired CSX's operating rights between Massillon and Wooster over NS.

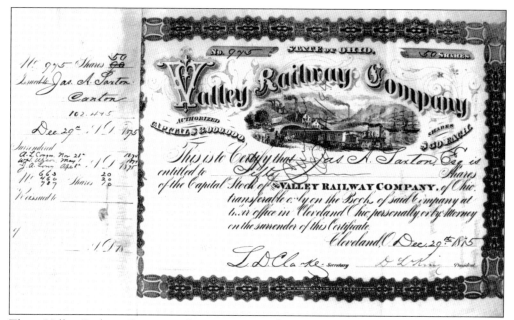

These Valley Railway Company shares were issued to Canton banker James A. Saxton. His daughter Ida married William McKinley, who became the 25th president of the United States in 1897. These shares were initially issued on November 28, 1874, to A. L. Conger, a partner in the company awarded the construction contract. Saxton acquired the stock on December 29, 1875, and it was cancelled on October 4, 1884. (Courtesy of the Paul Vernier collection.).

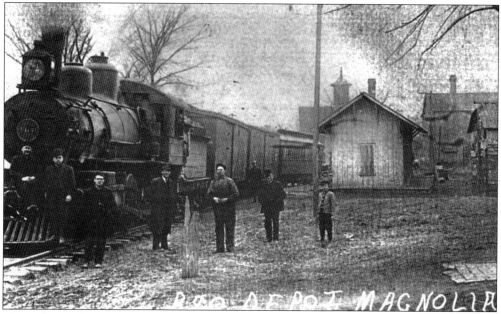

The Valley Railway built two short branches in the rugged country south of Canton. One ran between Mineral City and Huff Run while the other was built between Sandyville and Magnolia. A local train is shown at the Magnolia station in an undated photograph. The Magnolia branch, which followed Sandy Creek, was abandoned in 1924. Magnolia also was served by the PRR's Tuscarawas branch. (Courtesy of the Paul Vernier collection.)

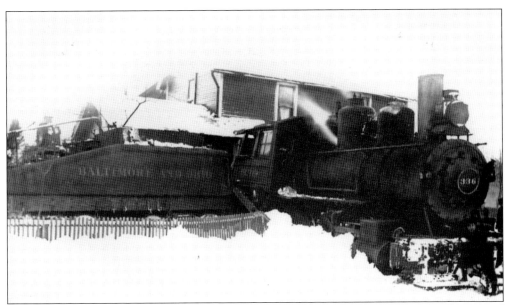

Snow building up on the B&O tracks near the intersection of Navarre Road Southwest and Market Avenue South in Canton caused this 1919 derailment. The wreckage damaged a nearby home, causing a floor to collapse and sending into the basement a woman baking bread in the kitchen. The woman suffered severe burns in the accident. No. 336 is a D-12 0-6-0-class locomotive. (Courtesy of the Paul Vernier collection.)

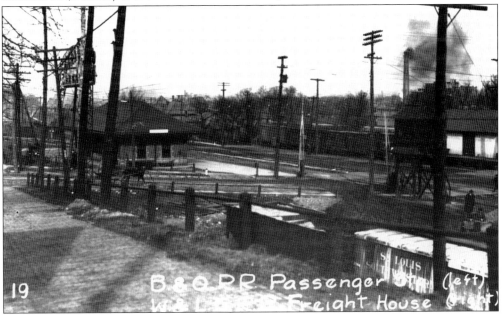

The last passenger trains to serve the B&O's Massillon station were Cleveland–Wheeling No. 258 and No. 259, which last ran on September 29, 1951. The B&O said the trains were losing $125,000 a year and wanted to end them in 1942. Instead the trains received renovated equipment, including a diner and sleeper. Steam-powered until the end, the trains briefly had gas-electric cars in May 1950. (Courtesy of Special Collections, Cleveland State University Library.)

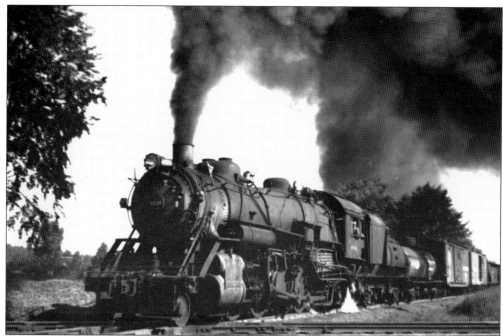

Although coal and iron ore were the primary commodities hauled by the B&O on the former CL&W, the route also hosted a handful of merchandise freights. The train shown in the photograph above may be the daily manifest freight from the Willard yard on the Chicago–Pittsburgh main line to Holloway that often worked at Massillon en route. Leading is No. 4836, a Q-7f-class 2-8-2 built by Baldwin Locomotives Works in 1916. The train is crossing the W&LE at Justus. In the photograph below, also recorded at Justus, a northbound coal train lumbers behind S-1-class No. 6181, a 2-10-2 built in the 1920s by Lima Locomotive Works. The 2-10-2 locomotives became mainstays on this route following World War II after diesel locomotives had displaced them from other assignments farther east on the B&O. (Photographs by Bob Redmond.)

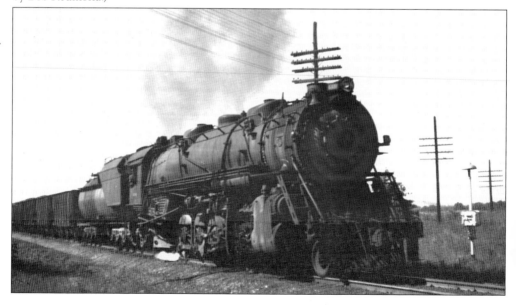

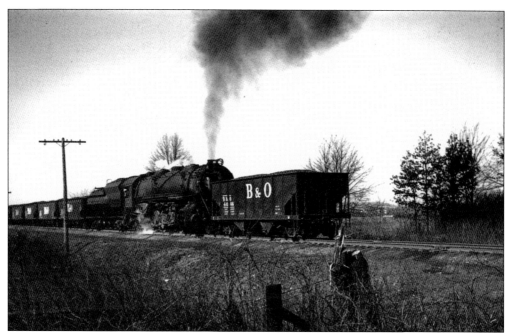

After a B&O coal hopper pulled a drawbar, the enterprising crew placed it in front of locomotive No. 521. The S-1-class 2-10-2 was near Justus when this view was captured on April 20, 1957. A falloff in freight traffic allowed the B&O to phase out steam power in early 1958. The last main line B&O steam operation was a Cleveland–Holloway excursion on May 17, 1958. (Photograph by Bob Redmond.)

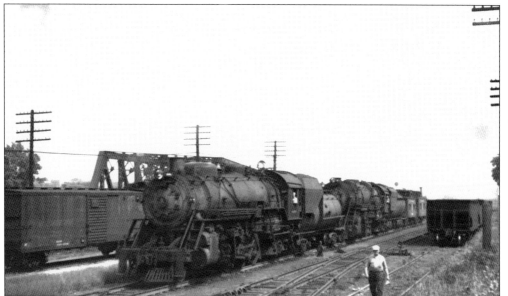

Trains on the B&O's former CL&W sometimes waited for hours to obtain permission to cross one of the many east–west main lines in northern Ohio. This prompted some employees to call their railroad the "Crawl, Linger and Wait." Led by Q-4b-class 2-8-2 No. 4463, a double-headed caboose hop is at Massillon in the early 1950s adjacent to the PRR and W&LE. (Photograph by Bob Redmond.)

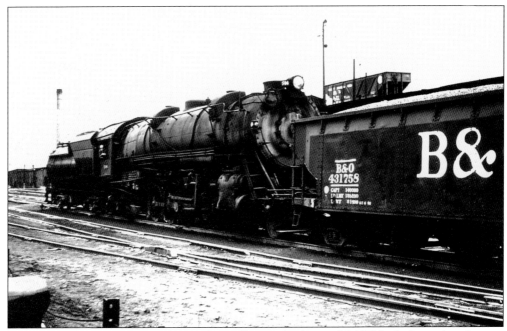

Holloway, located 60 miles southeast of Massillon on the former CL&W, had a large classification yard and locomotive shops that opened in 1904, displacing similar facilities at Urichsville. Situated between two B&O divisions, Holloway was a crew change point. Northbound trains originating near the Ohio River faced a 26-mile climb upgrade to Flushing and then a steep and short grade into Holloway, where they were broken up and reclassified into trains bound for Lorain, Cleveland, Akron, or Willard. In the photograph above, No. 506, an S-1-class 2-10-2, switches coal hoppers in the Holloway yard on April 20, 1957. That same day, No. 377, a Q-3-class, Mikado-type 2-8-2 built by Baldwin Locomotive Works in 1918, leads a coal train into Holloway (shown below). The Holloway yard, tracks, and shops are now abandoned. (Photographs by Bob Redmond.)

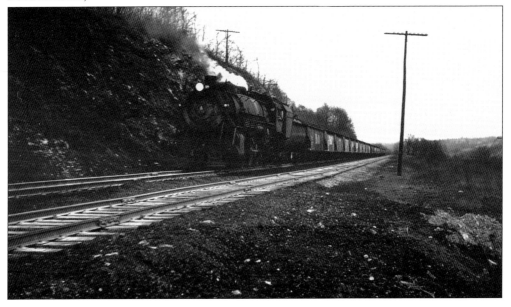

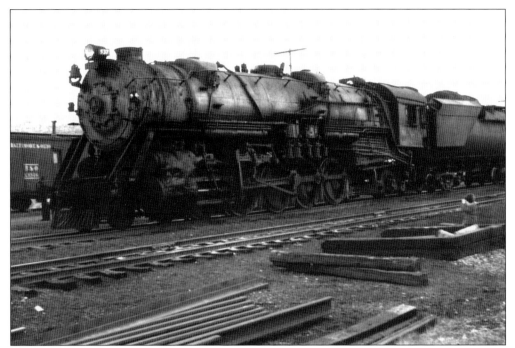

Much of the coal traffic on the B&O in northeast Ohio was seasonal because it hinged on the Great Lakes' shipping season. When the shipping season shut down between December and April, the number of B&O coal trains fell. Merchandise freight was steadier. Leading a manifest freight through Beach City on April 13, 1957, is S-1a No. 537, a 2-10-2 "Big Six." (Photograph by John Beach.)

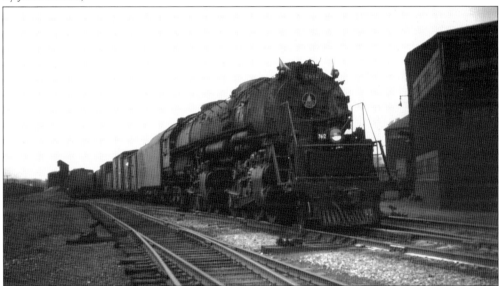

EM-1 locomotives were assigned to B&O lines in Ohio following World War II. The B&O's last articulated steam engines enabled the railroad to reduce by half the number of locomotives and crews needed to pull similar-size trains. Built by Baldwin in 1944, the 2-8-8-4 locomotives served through the end of steam. No. 7612 pauses at Dover in 1954. (Photograph by Ed Beckwith, courtesy of the Chris Lantz collection.)

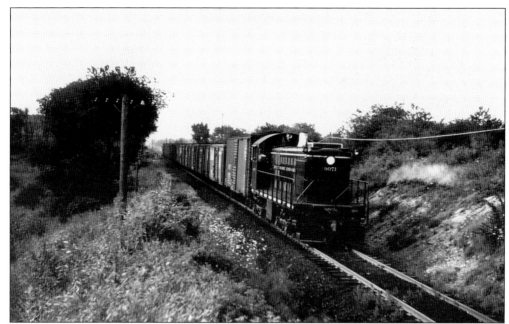

The B&O's Canton area freight business was handled by two Canton-based yard jobs and a local freight train operating between Canton and Valley Junction. Two daily turns operated between Akron and Canton. Canton had a four-track yard and a handful of spurs that meandered through town to various customers. Much of this business evaporated in the 1960s, and by the late 1970s, the Canton-based yard jobs and locals had been abolished or consolidated with the single local that operated out of Akron. In the photograph above, an Alco S-2 switcher hauls a string of empty freight cars southbound near Canton in July 1959. In the photograph below, a pair of GP9 diesels pulls cars on a freight spur on March 1, 1975. The spur occupied a short section of Navarre Road Southwest in Canton. (Photographs by John Beach.)

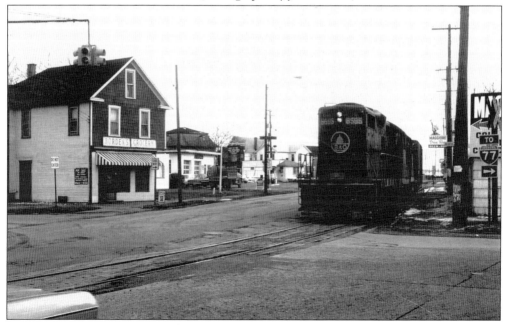

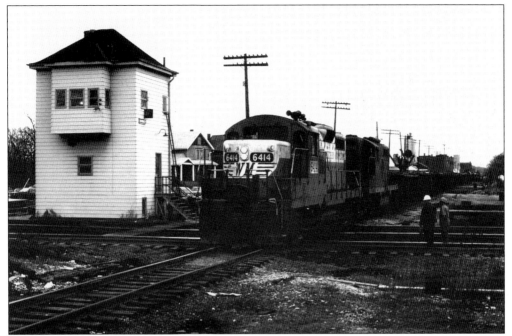

In 1976, the Chessie System assigned former Western Maryland Railway (WM) GP9 locomotives to the Canton line. Unlike similar B&O locomotives, the WM diesels did not have a high short hood. The B&O had long held nearly half of the WM's stock and in 1967, the B&O/C&O took control of the WM. WM No. 6414 leads a southbound freight past McKinley Tower in Canton on February 26, 1983. (Photograph by John Beach.)

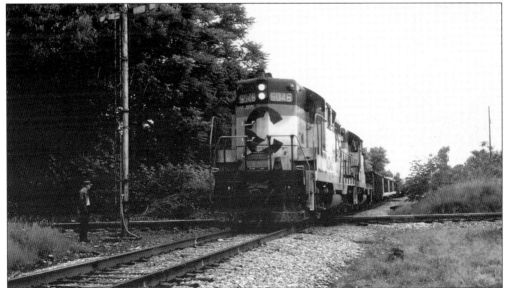

The B&O and W&LE crossed in Canton near Fifteenth Street Southeast. The target signals that guarded noninterlocked crossings had two indications. The horizontal position meant one railroad had control of the crossing while the vertical position favored the other railroad. Such signals were often used at crossings with little traffic. A Chessie System train makes its way through the crossing on June 17, 1981. (Photograph by John Beach.)

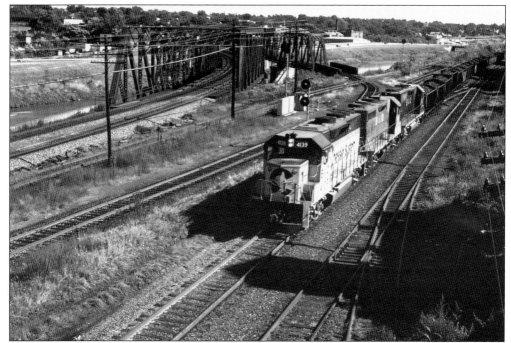

A northbound coal train passes through Massillon on the former CL&W line on September 23, 1973. Coal traffic sharply declined here due to a falloff in shipments of West Virginia coal to Great Lakes ports, Ohio coal falling out of favor due to its high sulfur content, and changes in dock operations. The Lorain coal dock closed after the Chessie System sold it to Republic Steel in 1980. (Photograph by John Beach.)

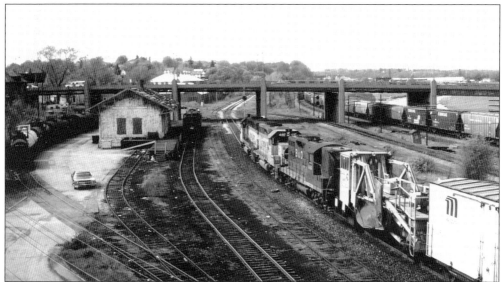

The B&O passenger station in Massillon was located just north of the freight station, shown in a view looking northward from the Tremont Avenue Southwest overpass. The bridge beyond the freight station is Lincoln Way East. The northbound Chessie System freight train is about to cross the former W&LE and may be delayed at Mace Tower by the Conrail train at the far right. (Photograph by John Beach.)

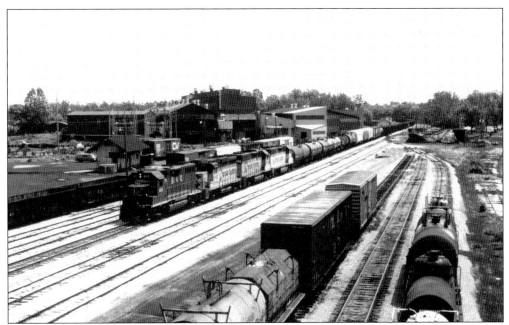

The B&O maintained a yard at Dover to handle local industries that included chemicals and steel. B&O GP38 No. 4813 leads a manifest freight into the Dover yard in June 1987. Although this facility was not nearly as large as others on the former CL&W, it still survives today as the operating headquarters of R. J. Corman Railroad Group, which owns the line between Clinton and Urichsville. (Photograph by John Beach.)

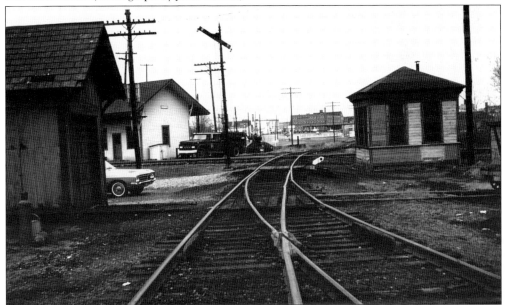

At many junctions south of Massillon on the ex-CL&W, B&O trains stopped short of the junction and, after determining there was no opposing traffic, set a target signal for their move. Shown is the target signal at the crossing of the B&O and PRR's Tuscarawas branch at Dover. The B&O passenger station is in the left background in this view looking eastward on the PRR. (Photograph by John Beach.)

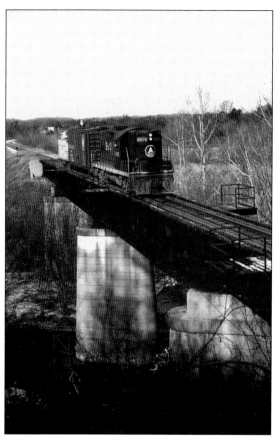

The terrain south of Canton transforms into the rugged unglaciated portion of the Allegheny Plateau. The Valley Railway generally built along creek valleys to Mineral City, but flood-control projects during the mid-1930s forced the B&O to relocate the line between East Sparta and Sandyville, resulting in construction of a high fill and four-span girder bridge over Sandy Creek, shown at left. B&O GP9 No. 6475 pulls a lone boxcar on January 15, 1972. At Mineral City, the B&O crossed two wooden trestles, the larger of which is shown below. This 860-foot bridge spans a Huff Run tributary and two roads. The two freight cars in front of the locomotive in this November 5, 1971, scene are bound for a customer at the end of the line not far from the end of this trestle. (Photographs by John Beach.)

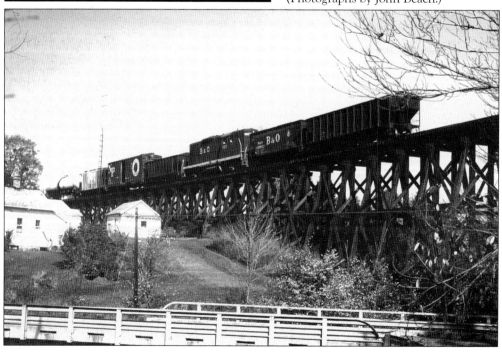

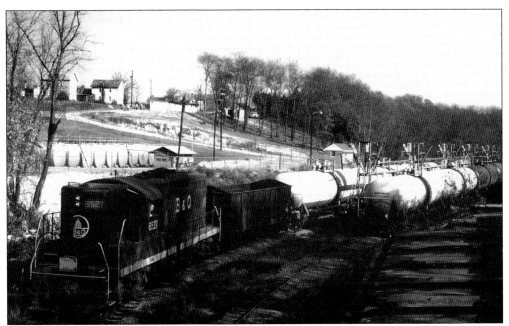

The B&O began serving the Witco Chemical oil rack at Lindentree in Carroll County about 1970. Located three miles east of Mineral City on the Huff Run branch, the location of the switch at Mineral City meant that trains had to back up to and from the facility, traveling 15 miles per hour. GP9 No. 6527 is shown above spotting cars at the oil rack on November 5, 1971. The 100 monthly carloads of oil moved to a Pennsylvania refinery. Partly because the Chessie System did not want to make extensive repairs to the wood trestles at Mineral City, it announced in mid-1977 plans to abandon the line south of Sandyville. But plans changed and rail service to the oil rack continued until May 1, 1985, when the last train backed down from Lindentree, shown in the photograph below. (Photographs by John Beach.)

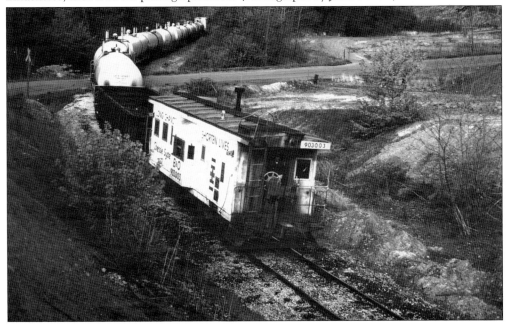

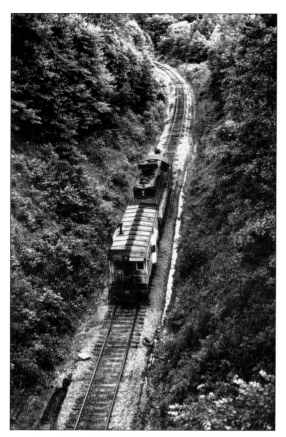

The last train passed through Rock Cut, an 80-foot-deep gorge in a ridge a mile north of Mineral City, on June 6, 1985, shown at left. Traffic had been falling for years and CSX did not care to pay for rebuilding the line, which had an 1896 truss bridge that could not handle more than 240,000 pounds. The last run to Mineral City, led by C&O GP9 No. 6161, picked up a car at the James Brothers mine loaded with California-bound coal. In the photograph below, track removal in Mineral City was well underway on April 6, 1986. The B&O once crossed the PRR's Tuscarawas branch here. The B&O used the PRR to reach Valley Junction after abandoning the last two miles of its own line into Valley Junction in 1938 during a flood-control project. (Photographs by John Beach.)

Five

WHEELING AND LAKE ERIE RAILWAY

The W&LE has had two incarnations under that name. The original W&LE passed out of existence on December 1, 1949, when the NKP leased it for 99 years. Both had been part of the Alphabet Route, a chain of railroads providing alternative fast freight service between the East Coast and Midwest in modest competition with the four trunk lines that dominated the region. The NKP and W&LE were a good fit because there was little overlap between them.

The NKP sought a merger partner after a spate of railroad consolidations were announced in the late 1950s. Among these were the New York Central System and PRR announcing merger talks in 1957, the Delaware, Lackawanna and Western Railroad merging with the Erie Railroad on October 17, 1960, and the C&O acquiring the B&O on February 14, 1963.

On October 16, 1964, the N&W merged with the NKP and also acquired the Akron, Canton and Youngstown Railway (AC&Y) and the Pittsburgh and West Virginia Railway (P&WV). This merger, combined with the N&W's merger with the Wabash Railroad, gave the N&W a formidable presence in the Midwest. Before the merger, the N&W's only Ohio routes had been its Cincinnati–Norfolk main line along the Ohio River and a route from Portsmouth to Columbus.

The N&W merged with the Southern Railway System on June 1, 1982, to form NS. Soon NS was selling light density or surplus routes to short line operators. In early 1990, an investment group, whose principals included two former Federal Railroad Administration officials and a former regional railroad operator, reached agreement with NS to acquire 578 miles of track and equipment that included most of the former W&LE, P&WV, and AC&Y.

The second W&LE began on May 17, 1990. With trackage rights agreements with NS, Conrail, and CSX, the new W&LE formed an 840-mile network in Ohio, Pennsylvania, West Virginia, and Maryland. It established its headquarters in Brewster in the same brick building used by the original W&LE as its main office.

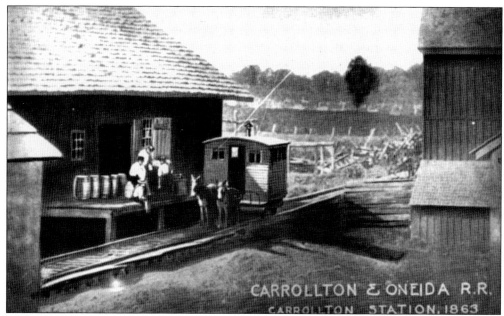

The Carroll County Railroad (CCR) operated over 10 miles of strap-iron rails between Carrollton and Oneida. The Cleveland and Pittsburgh Railroad (C&P) ceased using the CCR in 1855, and the CCR then purchased a 4-2-0 steam locomotive. When that locomotive quit running in 1859, the CCR relied on mules as shown in the drawing above. Reorganized in 1866 as the Carrollton and Oneida Railroad (C&O), it ordered a new steam locomotive, a 0-4-OT that it named *Carroll*. Shown in the photograph above, the *Carroll* began service on September 4, 1867. The C&O earned revenues of $3,555 in 1867 but had expenses of $10,397. The C&O was sold for $1 to the Ohio and Toledo Railroad in 1873 and eventually became the Carrollton branch of the W&LE. (Courtesy of Special Collections, Cleveland State University Library.)

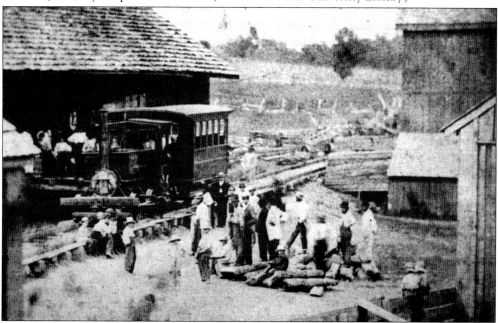

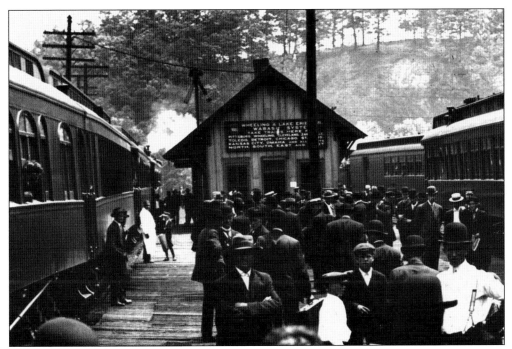

During Wabash Railroad control of the W&LE, Toledo–Pittsburgh through passenger service began on July 3, 1904, reaching Pittsburgh over the Wabash-Pittsburgh Terminal Railway. The trains featured through cars for Chicago and St. Louis with some of the latter going directly onto the grounds of the 1904 St. Louis world's fair. Passengers are shown at Navarre in 1904. This depot was razed in 1910. (Courtesy of Special Collections, Cleveland State University Library.)

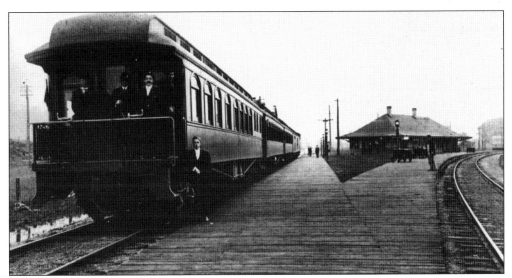

The W&LE began café-parlor service on May 30, 1900, featuring female hostesses, an uncommon practice then, wearing white uniforms. Café-parlor car service on the W&LE ended on September 14, 1931. Passenger consists in the 1930s were usually a coach, baggage car, and combination car. Toledo–Zanesville passenger service ended on May 31, 1932. Shown is a train at Harmon. (Courtesy of Special Collections, Cleveland State University Library.)

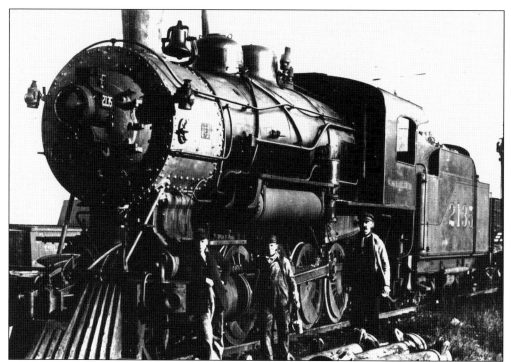

W&LE No. 2125 was an H-6-class 2-8-0 built in 1905 by the American Locomotive Company at the former Brooks Locomotive Works in Dunkirk, New York. Of the 50 members of this class, 8 survived into the NKP era before being scrapped. No. 2125 is shown with three crew members at Columbia Yard in Massillon in 1910. (Courtesy of Special Collections, Cleveland State University Library.)

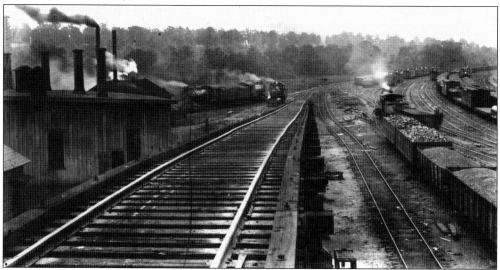

Columbia Yard in Massillon was a major classification yard for the W&LE in its early years. Located on the west side of the Tuscarawas River, the yard was long and crowded, which in part prompted the W&LE to develop the Brewster yard. This undated view is taken from the top of the coal tipple used to refuel steam locomotives. (Courtesy of Special Collections, Cleveland State University Library.)

The Connotton Valley Railway (CV) yard was located near downtown Canton but by the early 20th century was hemmed in and could not be expanded. The W&LE built Gambrinus Yard on Canton's south side along Snake Creek in 1920–1921. The yard had a capacity of 660 cars and handled six Cleveland–Canton trains plus locals and industrial switching jobs. The 10-stall brick roundhouse, shown above, opened on May 1, 1922. It continued in service into the N&W era, shown below in an image recorded on March 16, 1975. The roundhouse is in front of the oil tanks. The Timken roller bearing company and an Ashland Oil Company refinery later built facilities along the edges of Gambrinus Yard, which is still used by the modern W&LE. (Above, courtesy of Special Collections, Cleveland State University Library; below, photograph by John Beach.)

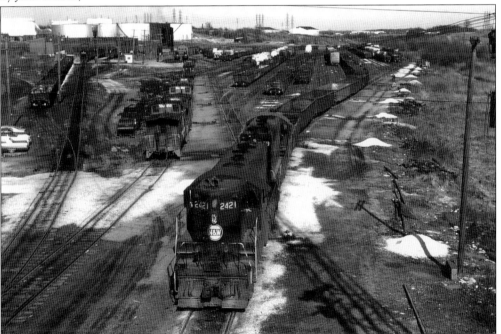

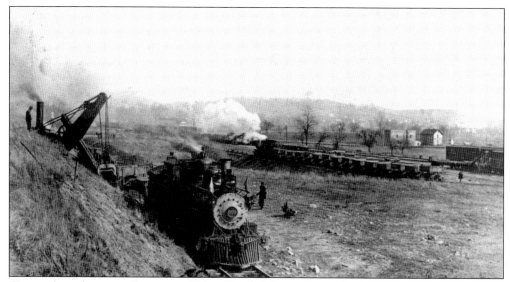

Cramped conditions at Canton and Massillon led the W&LE to build a new yard, headquarters, and locomotive and car shops on 625 acres of undeveloped land in southwest Stark County two miles west of Harmon. The complex was located in the geographic center of the W&LE. Construction of the yard, shown in the photograph above, began in 1906 but was slowed by a 1908 economic downturn. Finishing the project received greater urgency after fire destroyed the W&LE's primary shops in Norwalk on August 12, 1909. The yard opened on August 1, 1909. The locomotive shops were completed in spring 1910 and celebrated with an open house on July 4, shown in the photograph below. The town of Brewster, which was platted in 1906, grew up around the W&LE complex. (Courtesy of Special Collections, Cleveland State University Library.)

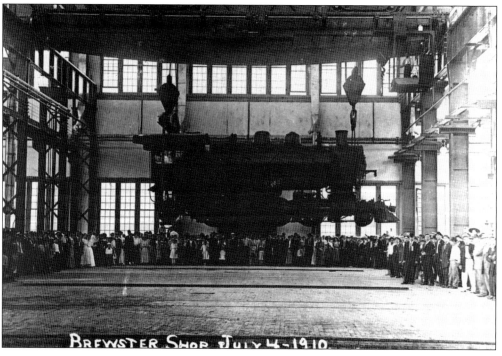

BREWSTER SHOP JULY 4-1910.

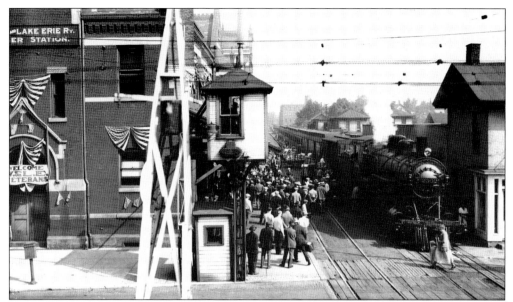

The W&LE was known for hauling coal, not passengers. Many W&LE passenger trains were expanded locals hauling milk, mail, and express shipments as well as people. Patronage peaked about 1911 and revenue began declining a decade later. In January 1927, the W&LE purchased three gasoline-electric cars that it hoped would cut its passenger expenses. This equipment later was assigned to the Canton–Massillon–Brewster employee shuttle trains. Although the W&LE route through Canton terminated at Zanesville, service between Cleveland and Zanesville had ended by 1933. In the final years of passenger service, Canton trains operated between Cleveland and Wheeling. The last scheduled W&LE passenger train operated between those points on July 17, 1938. A passenger special for World War I veterans is shown at the Canton station in both photographs. (Courtesy of Special Collections, Cleveland State University Library.)

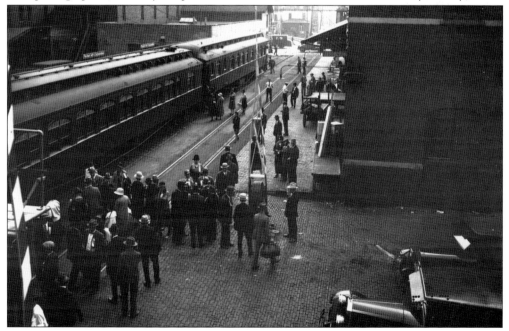

The CV built this passenger station in Canton in 1881 at Tuscarawas Avenue East and Savannah Avenue Northeast. The building, which housed the headquarters of the W&LE until May 10, 1914, featured a 96-foot clock tower. Shown is the south approach to the depot, which was demolished on November 16, 1938, after passenger service ended four months earlier. (Courtesy of Special Collections, Cleveland State University Library.)

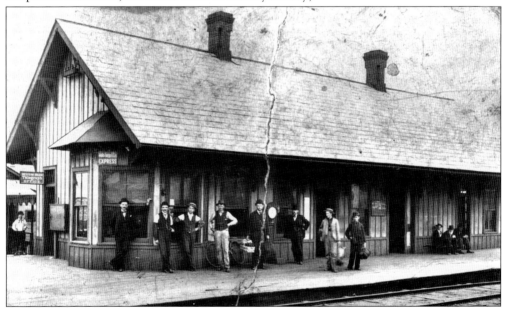

Many W&LE Brewster shops employees lived in Massillon or Canton and did not want to move. Until April 1, 1939, the W&LE operated a two-car employee shuttle train—nicknamed the "hoodlebug"—between Brewster and the Massillon station, shown here. In 1920, the W&LE offered 16 round-trip shuttles around the clock, including a pair operating between Brewster and East Greenville. (Courtesy of Special Collections, Cleveland State University Library.)

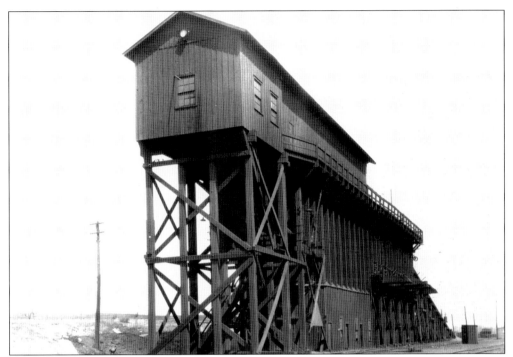

The largest coal dock on the W&LE was at Brewster. Opened in 1910, the dock had a 300-ton capacity and 10 chutes. Hopper cars were lifted 38 feet up a 20 percent grade to the top of the dock by rope. The dock, which also stored sand, last operated in 1957 and was demolished in 1961. (Courtesy of Special Collections, Cleveland State University Library.)

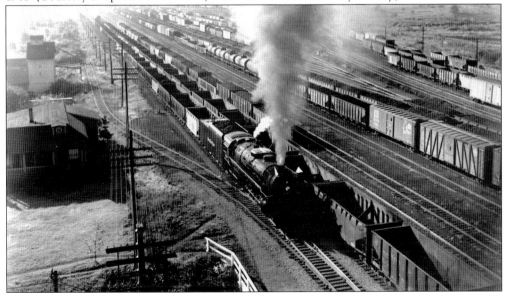

When opened in 1909, the Brewster yard had 25 miles of track and space for 3,300 freight cars. Although some believe Brewster was named for a Wabash Railroad official, it actually may have been named for an early settler, Calvin Brewster. The town was built around the railroad. The Brewster yards are shown in an early 1950s view from atop the headquarters building. (Courtesy of Special Collections, Cleveland State University Library.)

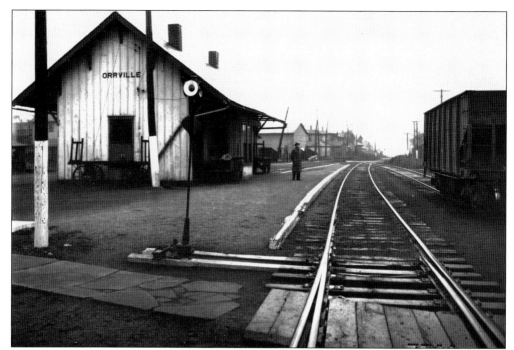

Orrville had two W&LE routes. The original Toledo–Wheeling main line came through town while the Brewster cutoff skirted the west edge. Where they met was named Orrville Junction. Through the 1920s, passenger trains served both routes. The W&LE in 1932 ended all passenger service except for one pair of Cleveland–Wheeling trains. The Orrville depot is shown in an undated photograph. (Courtesy of Special Collections, Cleveland State University Library.)

Like most railroads, the W&LE picked up and unloaded less-than-carload freight shipments at most of the towns along its tracks. Larger communities had a separate freight station, but in small towns such as Baltic on the Cleveland–Zanesville line, freight and passengers shared the same depot. A W&LE freight train pauses at Baltic in an undated photograph. (Courtesy of Special Collections, Cleveland State University Library.)

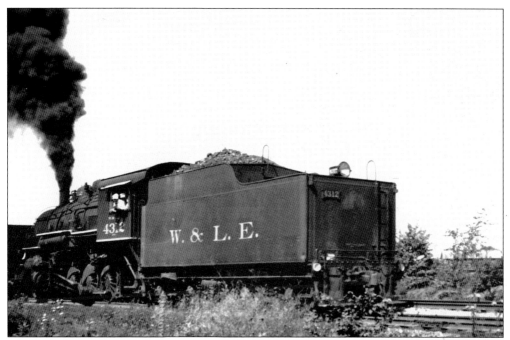

Engineer John S. Foster regularly operated for many years W&LE No. 4312, an H-class 2-8-0, shown switching at Brewster. Foster began with the W&LE as a trackman in 1891, became a fireman in 1896, and became an engineer in 1910. His last regular assignment was on a Brewster–Massillon local. Foster and the No. 4312 both retired on December 10, 1949. (Photograph by Bob Redmond.)

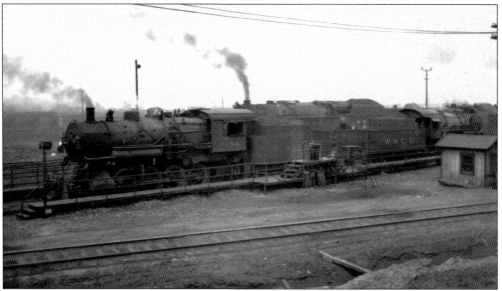

W&LE steam locomotives are clustered at the service facility in Brewster awaiting their next assignments. No. 4156 (facing leftward) is a 2-8-0 that was assembled at the Brooks Locomotive Works in Dunkirk, New York, in April 1905. When this image was recorded in the late 1940s, No. 4156 was living on borrowed time. It was sold for scrap on March 20, 1953. (Photograph by Bob Redmond.)

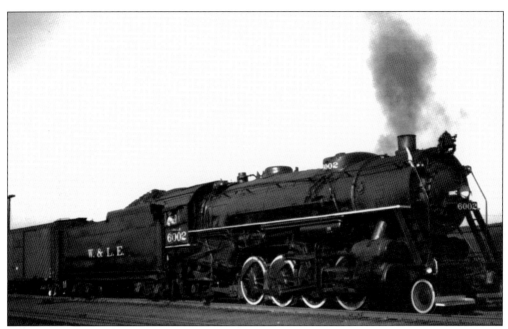

This heavy 2-8-2 Mikado-type steam locomotive was designed by the United States Railway Administration, which controlled the nation's railroads during World War I. No. 6002, shown working in the Brewster yard in the late 1940s, was built by the American Locomotive Company at the former Brooks Locomotive Works plant in August 1918 at Dunkirk, New York. It was sold for scrap in October 1955. (Photograph by Bob Redmond.)

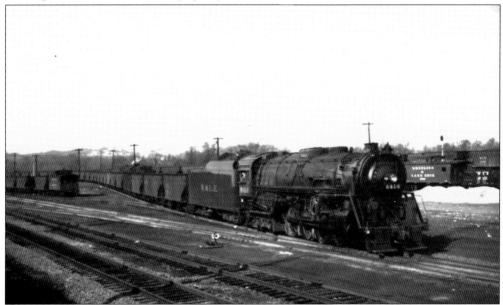

Until the early 1920s, the top freight commodities carried on the W&LE were coal and iron ore. A train of coal hoppers leaves Brewster for the mines in the late 1940s behind 2-8-4 No. 6414, a K-1 locomotive built by the American Locomotive Company in January 1939. The W&LE's 32 K-1s were modeled after a Berkshire-type locomotive of the NKP. (Photograph by Bob Redmond.)

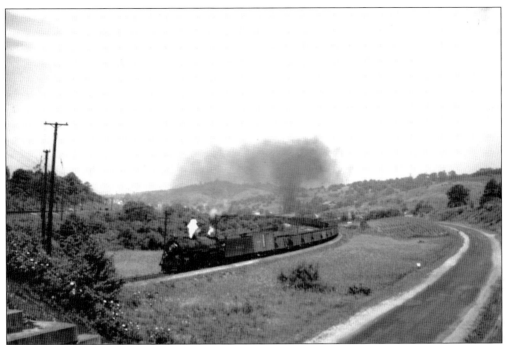

By 1924, the W&LE's principal freight business was manufactured goods. Much of this freight came from the many steel mills, foundries, rubber plants, and machine shops spread over its system. Some of this freight was bound for automobile assembly plants in Michigan and was interchanged at Toledo. A W&LE manifest freight is about to pass beneath the PRR's Pittsburgh–St. Louis line at Jewett. (Photograph by Bob Redmond.)

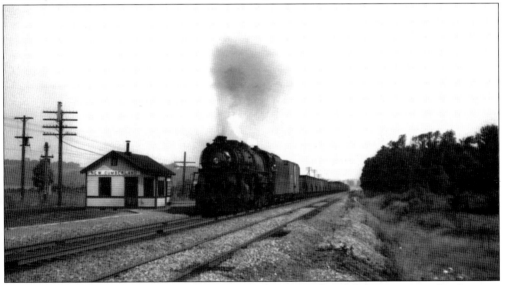

The W&LE was part of the Alphabet Route, a Chicago and mid-Atlantic region freight route that competed with the four dominant trunk lines. Other Alphabet Route members included the NKP, P&WV, WM, Reading Company, and Central Railroad of New Jersey. A W&LE train rushes past New Cumberland in northeast Tuscarawas County behind K-1-class No. 6425. (Photograph by Bob Redmond.)

Diesel locomotives with Denver and Rio Grande Western Railroad (D&RGW) heritages are common on the modern W&LE because W&LE chairman Larry Parsons is a former D&RGW executive who brought several ex-D&RGW managers with him when he came to the W&LE on April 1, 1992. The original W&LE also had a D&RGW connection, having acquired two former D&RGW 4-8-2s. One of them, No. 1553, is shown above at Brewster in 1948. Rebuilt in July 1948 and renumbered No. 6810, the locomotive was heavily damaged in a fire the following March at Norwalk. Although repaired, No. 6810 was retired a month later. In the photograph below, D&RGW No. 5413, an SD40T-2 still wearing its original D&RGW livery, works a train at Justus on June 1, 2008. (Above, photograph by Bob Redmond; below, photograph by Peter Bowler.)

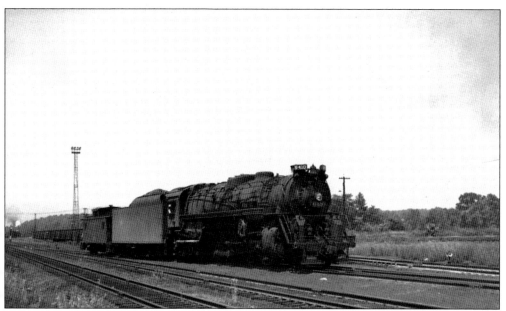

The NKP continued to maintain steam locomotives assigned to the former W&LE territory at the Brewster shops. The last steam locomotive to be overhauled at Brewster was released on June 23, 1955. Two years later, the last steam locomotive on the former W&LE dropped its fires on November 29 at Brewster. NKP No. 6410 is shown at Brewster in the early 1950s. (Photograph by Bob Redmond.)

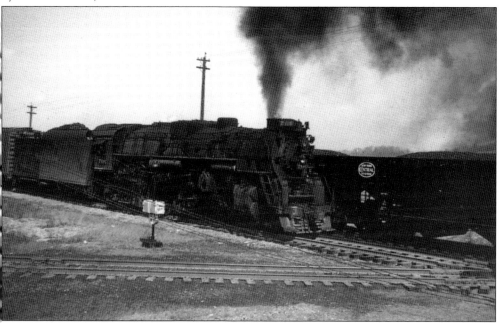

The busiest segment of the W&LE was the double track between Brewster and Harmon. Pittsburgh Junction–Harmon was the busiest single-track railroad in the country in 1910, but the W&LE's directors refused to authorize double tracking. NKP No. 706, a 2-8-4 built by Alco in 1934, is about to cross the B&O at Justus as a coal train heads into the Brewster yard. (Photograph by Bob Redmond.)

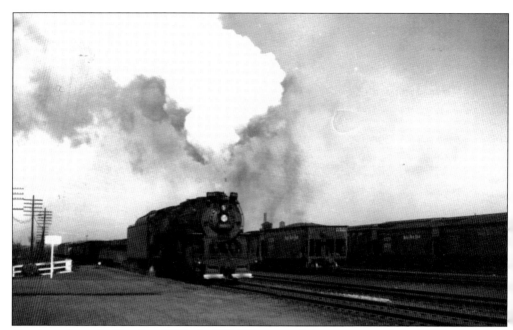

Consistently profitable after 1920, the W&LE attracted the attention of the NKP, which had inherited John D. Rockefeller's W&LE stock. Acquiring the W&LE gave the NKP access to areas of Ohio and West Virginia that it did not serve. NKP No. 803, an Alco-built 2-8-4 that was formerly W&LE No. 6403, arrives in Brewster. Built in April 1937, No. 803 was scrapped in May 1961. (Photograph by Bob Redmond.)

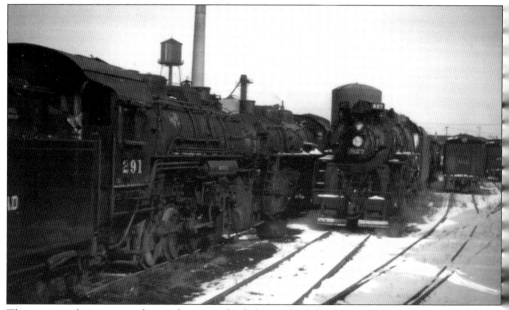

These steam locomotives have about reached the end of their service lives as they huddle at Brewster in the mid-1950s awaiting their fate. No. 291 is a 0-8-0 built in Brewster by the W&LE in May 1930 while No. 827 is an Alco 2-8-4 built in August 1942. Both were scrapped, and only two W&LE steam locomotives have survived. (Photograph by Ed Beckwith, courtesy of the Chris Lantz collection.)

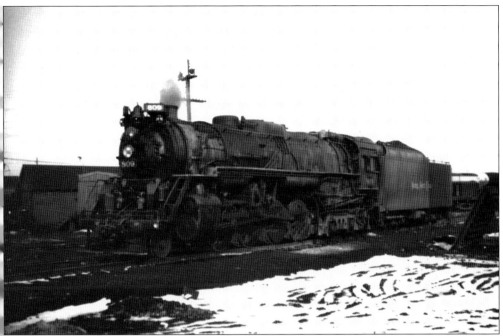

The NKP operated several ex-W&LE locomotives. Although W&LE locomotives were relettered and renumbered, the footboards located next to the pilots often were a tip-off to the W&LE heritage of the engine. NKP No. 809, formerly W&LE No. 6409, waits for another assignment at Brewster in the early 1950s. Built by Alco in April 1937, No. 809 was sold for scrap in October 1961. (Photograph by Bob Redmond.)

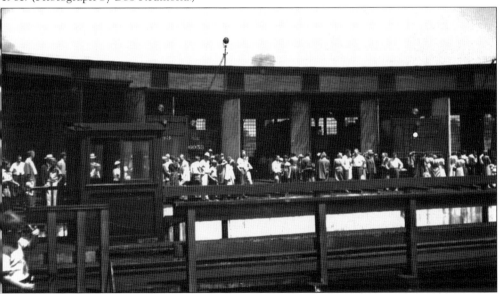

The 26-stall Brewster roundhouse opened in 1910 adjacent to the locomotive and car shops. Employment peaked in December 1920 at 345 workers. Those in this late-1940s view are aboard an excursion train stopping in Brewster for a tour of the yard and shops. The NKP razed the roundhouse in January 1960, but the turntable, which was rebuilt in 1945, is still used. (Photograph by Bob Redmond.)

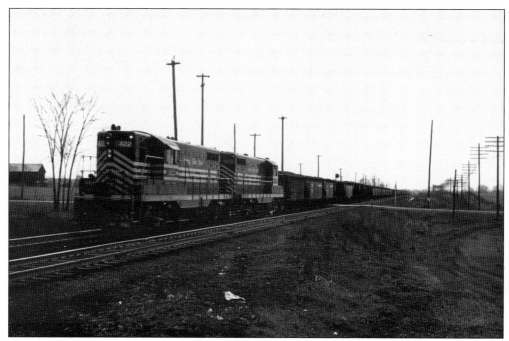

The first NKP diesel locomotives assigned to former W&LE territory arrived on January 28, 1953. The W&LE had just four diesels, Electro Motive Corporation NW-2 switchers dating to 1940 that usually worked in Toledo. Shown are NKP GP7 No. 422 and No. 413, both built in early 1953, at Harmon on April 20, 1957. The geeps were retired in March 1982 and August 1983, respectively. (Photograph by Bob Redmond.)

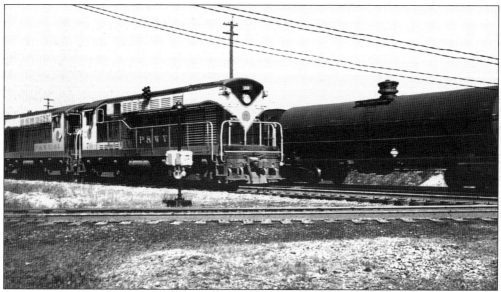

The W&LE and P&WV agreed on May 18, 1934, to pool locomotive power between Brewster and Pittsburgh. Built by the Wabash Railroad in 1904 as the Wabash-Pittsburgh Terminal Railway, the 60-mile railroad was reorganized in 1916 as the P&WV. It built an extension to Connellsville, Maryland, in 1931. P&WV No. 70 and No. 64, both Fairbanks-Morse H20-44 diesels, lead an eastbound train at Justus on April 20, 1957. (Photograph by Bob Redmond.)

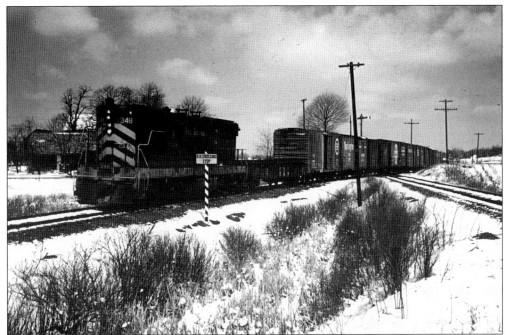

NKP No. 348, an SD9 built in April 1957 by the Electro-Motive Division of General Motors Corporation, leads a northbound manifest freight through the crossing at Justus of the B&O's former CL&W line to Wheeling with the NKP's Cleveland–Zanesville line on March 18, 1967. No. 348 would later serve the N&W, as well as NS, before being retired on December 26, 1985. (Photograph by John Beach.)

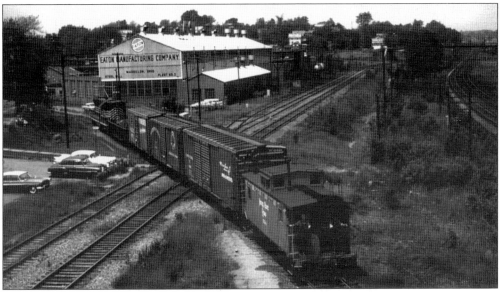

W&LE trains faced a 1 percent grade at Sippo Summit four miles west of Massillon that required double-heading or helper locomotives. This led the W&LE to build a new route between Bolivar and Orrville that opened in 1909. The original route was abandoned in the early 1950s between Orrville and Dalton. A local bound for Dalton crosses the B&O in Massillon on June 6, 1963. (Photograph by John Beach.)

The N&W consolidated dispatching of former W&LE and P&WV lines at Brewster. Routes with centralized traffic control (CTC) are displayed on this panel on March 5, 1978, when the dispatching office was new. The W&LE installed CTC between Brewster and Adena in 1945 and between the Brewster and Bellevue route in 1947–1948. The last CTC on the former W&LE—between Spencer and Belleveue—was decommissioned in 2000. (Photograph by John Beach.)

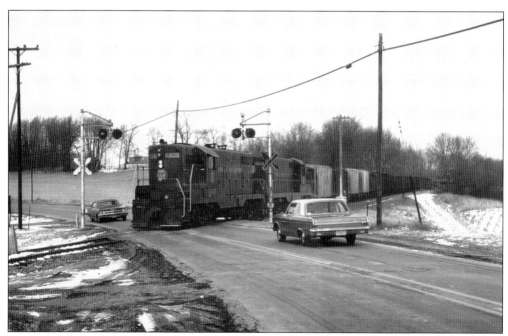

Many NKP locomotives continued in N&W service. N&W No. 2435 and No. 2415 were originally NKP No. 435 and No. 415, respectively. Both GP7 locomotives were built in 1953. No. 2415 was retired in September 1979, but No. 2435 served NS as No. 1435 before being retired in April 1984. The train is shown at Beach City on February 21, 1972. (Photograph by John Beach.)

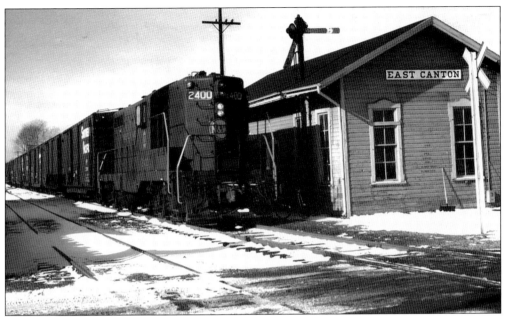

Founded in 1806 as Osnaburg, Stark County's second-oldest community boasted a stagecoach stop and seven hotels. The CV's Carrollton branch arrived in 1880. Anti-German sentiment during World War I led the town to change its name to East Canton. Business seemed to be good on the branch as N&W GP7 No. 2400 pulls a string of boxcars on December 30, 1968. (Photograph by John Beach.)

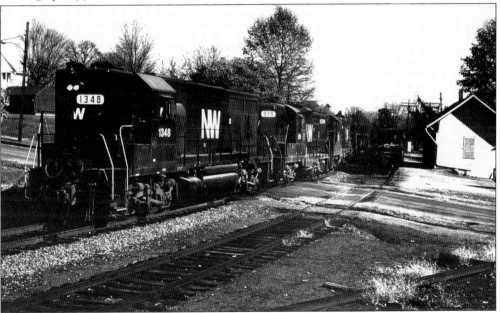

Navarre, a 19th-century canal center, resulted from the April 1872 merger of three villages, the oldest of which was founded in 1806 as Bethlehem. The CV laid tracks down Second Street whereas the W&LE built on the southern edge of town, crossing the Tuscarawas River at Rose Hill. An N&W freight passes through Navarre in November 1981. (Photograph by John Beach.)

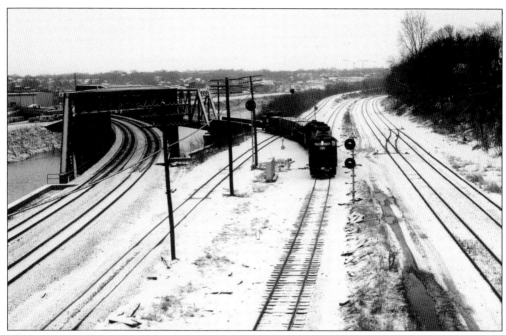

The N&W and the B&O used a single-track bridge adjacent to the PRR bridge over the Tuscarawas River in Massillon. The N&W had a freight station on the other side while the B&O had a handful of freight customers. An N&W local is coming off the bridge, crossing the PRR's South Massillon branch in this early 1981 view. The B&O tracks are at the far right. (Photograph by John Beach.)

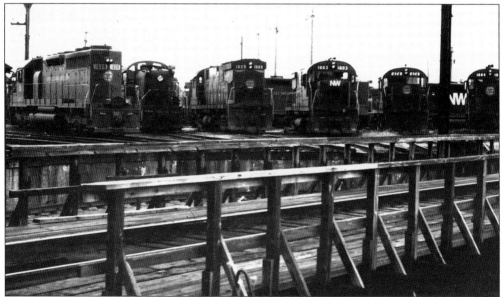

Some believe NS spun off the former W&LE and P&WV in 1990 to address antitrust concerns raised by a 1986 U.S. Justice Department review of NS's failed plan to purchase Conrail, which would have suppressed competition in some areas of the Chicago–Pittsburgh corridor. That was in the future on August 27, 1972, as a variety of N&W locomotives reposed at the former Brewster roundhouse site. (Photograph by Jeff Darbee.)

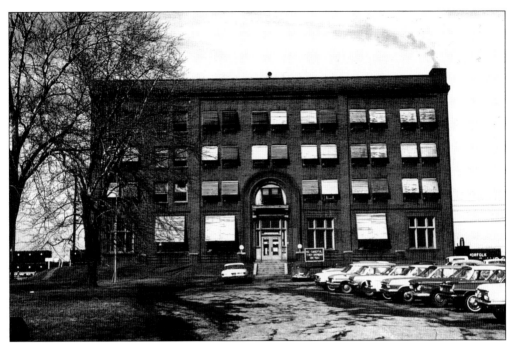

Construction of the W&LE's four-story headquarters began in 1913 and was completed on June 1, 1914. "The brick," as generations of railroaders have called it due to its brick construction, also housed the Brewster passenger station. It continued as railroad offices after the 1949 NKP merger, although for a time a savings and loan company also used the building. This view was recorded on March 24, 1967. (Photograph by James McMullen.)

The massiveness of the W&LE's Brewster yard and shop complex is evident in this aerial view taken from 1,000 feet. The plane is over the west edge of the yard, and the view is looking toward the southeast. Although the modern W&LE maintains yards at Pittsburgh, Canton, and Akron, the Brewster yard remains by far the W&LE's largest and busiest yard. (Photograph by John Beach.)

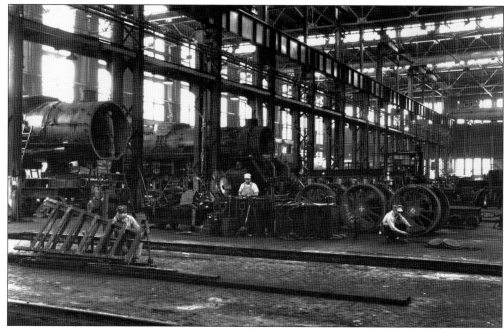

The Brewster shop featured 3.2 acres under roof, 18 bays, and 38 erecting pits. Aside from overhauling steam locomotives, as shown in the photograph above, the shop also built 50 0-6-0 and 0-8-0 switchers in the 1920s and 1930s. It continued to overhaul NKP steam and diesel locomotives, but in the N&W era, work was limited to running locomotive repairs. The shop closed in the late 1980s. When the modern W&LE began in 1990, the roof leaked and there was no heat. The W&LE has poured more than $1 million into renovating the shop, whose 32 employees repair the W&LE's GP35 and SD40 diesels. The shop, shown below in November 2000, also does contract work for nearby regional and short line railroads and for steel mills. (Above, courtesy of Special Collections, Cleveland State University Library; below, photograph by Craig Sanders.)

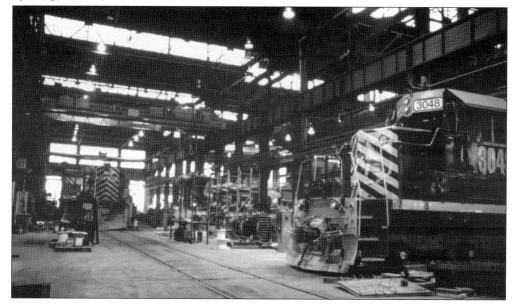

W&LE train No. 353 is approaching the middle ladder (seen at right) inside the Brewster yard in a view captured in November 2000 from the locomotive. Straight ahead is the west end of the westbound yard. An average of 21 trains a day arrive and depart from the Brewster yard. Remote-controlled locomotives do some switching in the yard. (Photograph by Chris Lantz.)

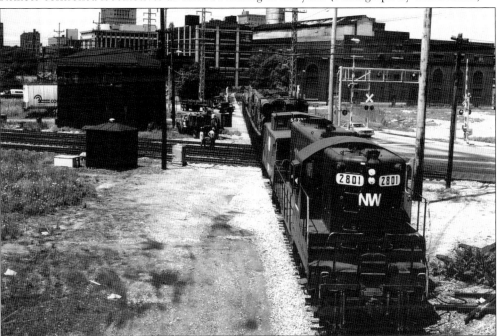

The Conrail maintenance crews who are out maintaining the diamonds at Wandle in Canton have stepped aside to allow a southbound N&W freight train to cross on August 10, 1983. The original CV yard in Canton was located just behind the photographer, who captured this view by climbing onto the home signal for northbound trains at the crossing. (Photograph by John Beach.)

Once facing abandonment, the Carrollton branch was saved when the State of Ohio funded a track rehabilitation project that included new ties, angle bars, and ballast. By the early 21st century, the line had just three small customers at Carrollton. The weekly local to Carrollton, led by high-hood GP35-3 No. 104, is about to cross the bridge over Sandy Creek at Oneida on May 25, 2008. (Photograph by Peter Bowler.)

The Carrollton branch features a 701-foot tunnel through Hog's Back Ridge just east of Robertsville. The westbound Carrollton local emerges from the tunnel in March 1996 led by GP35 No. 2650 still wearing Southern Railway System colors. That same year, a boxcar became wedged in the tunnel, causing railroad officials to fear that it might collapse when the car was pulled out. It did not. (Photograph by Marty Surdyk.)

Six

Ohio Central Railroad System

The roots of the Ohio Central Railroad System date to May 1, 1984, when Jerry Joe Jacobson purchased a controlling interest in Ohi-Rail Corporation, which operated 34 miles of state-owned track between Minerva and Hopedale in eastern Ohio. Jacobson had developed a passion for railroads while growing up in Cuyahoga Falls and watching B&O steam-powered trains.

Jacobson subsequently became involved in the Ohio Southern Railroad, which began providing service in September 1985 over another state-owned light-density traffic line south of Zanesville. A year later, the Mahoning Valley Economic Development Corporation asked Jacobson to operate a four-mile former Erie Railroad industrial branch, giving birth to the Youngstown and Southern Railroad.

NS was looking to shed routes in Ohio, and Jacobson lobbied NS to sell him the former CV between Harmon and Zanesville. The sale closed on April 16, 1988, and Jacobson named the property the Ohio Central Railroad (OC).

It was the second railroad to carry that moniker, the original OC having been organized in 1869 as the Atlantic and Lake Erie Railway with plans to build between Toledo and Pomeroy. It adopted the OC name in 1876 and became the Toledo and Ohio Central Railway (T&OC) after leaving receivership in 1885. The T&OC eventually operated two routes southward from Toledo, one of which passed through Columbus and terminated in Charleston, West Virginia. The T&OC affiliated with the New York Central System in 1910.

Jacobson sold his interest in Ohi-Rail to focus on developing the OC. He continued to acquire agreements to operate rail routes, the largest of which was the former PRR route between Mingo Junction and Columbus. An OC subsidiary, the Columbus and Ohio River Railroad began operating this line on April 16, 1992. The OC eventually included 10 subsidiary railroads operating 500 miles of track in eastern and southern Ohio and the Pittsburgh area.

In August 2008, the OC announced it was being sold for $219 million to Connecticut-based Genesee and Wyoming, Inc., an operator of 52 short line and regional railroads around the world. The sale closed on October 1.

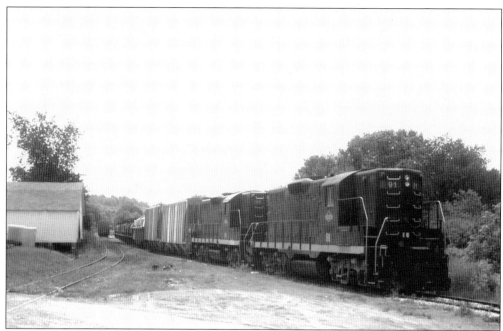

In April 1988, NS sold to Jerry Joe Jacobson the Harmon–Zanesville segment of the former CV route. Jacobson renamed it the OC. The route had a fairly diverse mixture of freight, including steel, coal, brick, lumber, plastics, clay, and rubber. However, it was not a high-volume freight line and NS was reluctant to provide the daily switching that many customers required. Not so the OC, which considered providing switching for customers to be an integral part of its business. In the photograph above, a pair of OC geeps painted in the company's then-utilitarian black livery await a new crew at Baltic in August 1992. In the photograph below, a pair of geeps, one still wearing Chessie System colors, leads a train between Sugar Creek and Barrs Mills in May 1989. (Photographs by Marty Surdyk.)

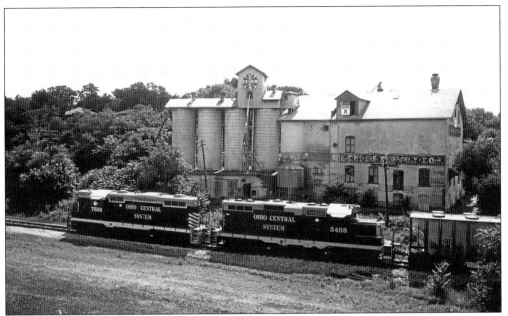

The OC has trackage rights over the R. J. Corman Railroad Group (former B&O) between North Beach City and Clinton (Warwick) where the OC interchanges cars with CSX. One of the top commodities that the OC receives from CSX at Warwick is coiled steel rolled by AK Steel Corporation's mill in Butler, Pennsylvania, and delivered to another AK Steel plant on the OC in Zanesville. The 239-mile move involves five railroads. In recent years, the OC has begun picking up at Warwick cars loaded with trash, much of it construction and demolition debris, bound for landfills near Zanesville or Apex. In the photograph above, a pair of former Conrail locomotives leads the Warwick turn through Massillon in August 1996. In the photograph below, the Warwick turn is just south of Clinton. (Above, photograph by Marty Surdyk; below, photograph by Peter Bowler.)

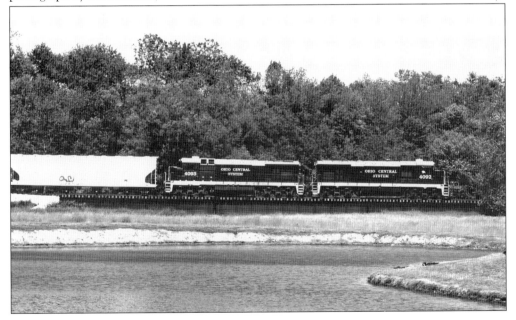

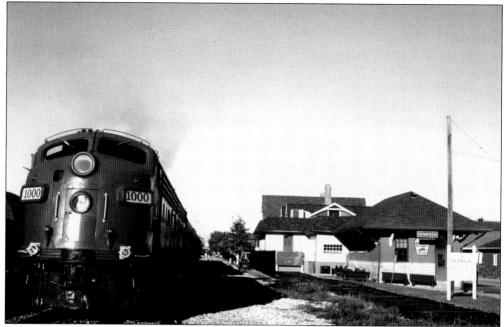

No. 1000 and sister unit No. 1001 were built in 1951 and 1950, respectively, for the Milwaukee Road and had two other owners before coming to the OC. Although these F7A locomotives were used in freight service, they eventually were reserved for passenger train and special event use. No. 1000 idles at the Dennison depot in October 2000 before pulling an excursion train. (Photograph by Marty Surdyk.)

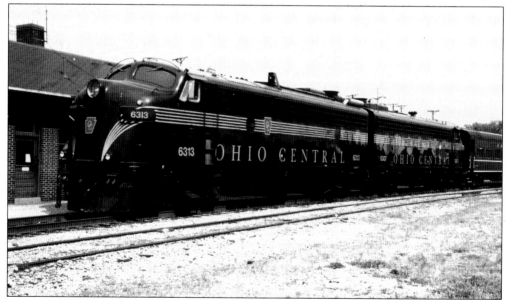

The sharpest-looking OC diesels were F9A No. 6307 and No. 6313, built for Canadian National Railways and later used by VIA Rail Canada. The livery of Tuscan red and gold pinstripes was similar to that worn by PRR locomotives that once traveled tracks now used by the OC. The OC has since sold these locomotives, which are shown at Sugar Creek on October 2, 2004. (Photograph by Craig Sanders.)

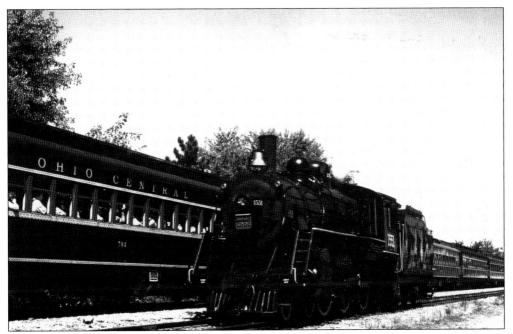

No. 1551 typically provided the motive power for the OC's Sugar Creek–Baltic tourist trains that operated between 1989 and 2003. The 4-6-0 was built by Montreal Locomotive Works in 1912 for Grand Trunk Western Railway, which later became part of Canadian National. Retired by Canadian National in 1958, No. 1551 was acquired by Jerry Joe Jacobson in 1986. It is shown running around the tourist train at Baltic in September 1995. (Photograph by Marty Surdyk.)

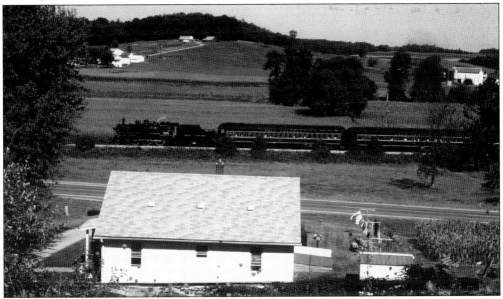

The OC once hosted steam-powered public excursions over its system. Passengers rode in heavyweight open-window coaches painted maroon, red, and black with yellow stripes and lettering. No. 1551, which Jerry Joe Jacobson acquired in 1986 from the Steamtown USA museum, pulled its first excursion train in October 1988. No. 1551 leads a train on July 3, 1995, past farms between Sugar Creek and Baltic. (Photograph by Marty Surdyk.)

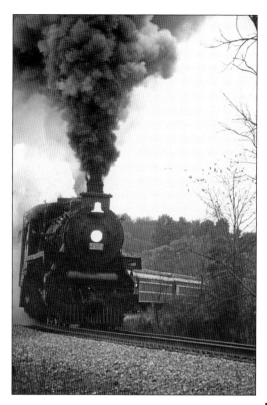

No. 1293, a Pacific-type 4-6-2 built in 1948 for Canadian Pacific Railway, was acquired by the OC in 1996 from Steamtown USA. A year later, it began pulling the Sugar Creek–Baltic tourist trains. Rebuilt in 2001–2002, No. 1293 smokes it up for the cameras during a photograph run-by at Fresno on October 2, 2004, during a Sugar Creek–Morgan Run excursion for the Akron Railroad Club. (Photograph by Craig Sanders.)

A passion for steam locomotives prompted Jerry Joe Jacobson (center) to implement the OC steam program. In 2008, he owned 10 steam locomotives, some of which needed rebuilding. The OC no longer offers public steam-powered excursions, but Jacobson's steam engines occasionally pull excursion trains on the Cuyahoga Valley Scenic Railroad (CVSR). The steamers sometimes pulled freight trains when Jacobson still owned the OC. (Photograph by Craig Sanders.)

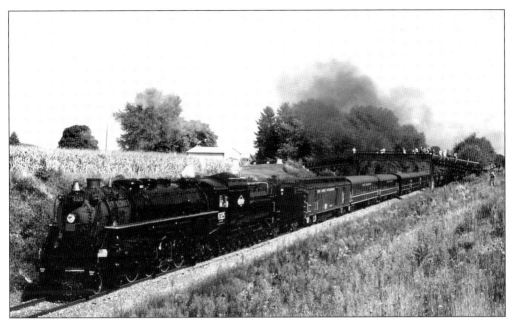

Built in 1942 by Alco for the Grand Trunk Western Railway and retired in 1959, Northern-type 4-8-4 No. 6325 joined the OC steam fleet in 1993. Rebuilt at the OC's Morgan Run shops, it ran under its own power on July 31, 2001, for the first time in nearly 40 years. No. 6325 is at West Lafayette in October 2001 during its first public excursion. (Photograph by Marty Surdyk.)

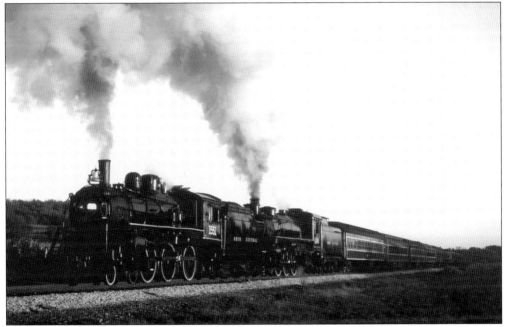

Some OC excursion trips featured double-heading steam locomotives, including this October 10, 1998, trip sponsored by the Akron Railroad Club. No. 1551 and No. 1293 provided the power for the trip that originated at Sugar Creek and carried 360 passengers. Cloudy conditions on this day gave way to sunny skies late in the day just in time for the traditional photograph run-by. (Photograph by Marty Surdyk.)

Making the OC steam program work were a combination of OC employees and volunteers working behind the scenes at the railroad's Morgan Run shops rebuilding and maintaining the steam and diesel locomotives assigned to excursion service. Shown in the photograph above is OC engineer Scott Czigans at the controls of F9A No. 6307 during an October 22, 2005, excursion for the Akron Railroad Club. The train, returning to Dennison from Morgan Run, is approaching West Lafayette on the former PRR's Pittsburgh–St. Louis line. In the photograph below, Czigans is firing No. 1293 during an October 7, 2006, Akron Railroad Club excursion. The engineer is Andy Novak. The Morgan Run shops were built in 1995 on 14 acres of farmland at the intersection of the Columbus and Zanesville lines east of Coshocton. (Photographs by Craig Sanders.)

Seven

OTHER RAILROAD OPERATIONS

Amtrak's May 1, 1971, inception dramatically reduced intercity rail passenger service in northeast Ohio. Amtrak kept one of the four pairs of Penn Central passenger trains on the former PRR route through Canton but chose not to serve stations at Wooster, Massillon, Alliance, and Salem. The discontinuance of four B&O passenger trains through Akron and six Penn Central trains through Cleveland left Canton as Amtrak's sole northeast Ohio station.

Amtrak kept one of two pairs of Penn Central passenger trains on the Pittsburgh–St. Louis ex-PRR route. The *Spirit of St. Louis* was renamed *National Limited* on November 14, 1971, and discontinued on October 1, 1979, in a route restructuring prompted by cuts in Amtrak's federal funding.

Amtrak's *Broadway Limited* linked Chicago and New York and had a Washington, D.C., section that diverged at Harrisburg, Pennsylvania. The Washington section was named *Capitol Limited* on October 1, 1981, when it began separating from the *Broadway Limited* at Pittsburgh. An increase in mail traffic prompted the separation of the *Capitol Limited* and *Broadway Limited* west of Pittsburgh on October 26, 1986, thus giving Canton four daily Amtrak trains.

During the 1980s, Conrail downgraded the former PRR main line in Indiana and western Ohio. After Conrail made Amtrak responsible for all maintenance costs of a 19-mile stretch of track between Gary and Valparaiso, Indiana, Amtrak rerouted the *Broadway Limited* and *Capitol Limited* away from Canton. On November 11, 1990, the *Broadway* began serving Akron while the *Capitol* was rerouted through Cleveland and Alliance.

The vanishing passenger train gave rise to excursion train operators, including the Orrville Railroad Heritage Society (ORHS), the Elderberry Line, and the Minerva Scenic Railway. Only the ORHS is still operating.

Perhaps the least visible railroad operations are those of Canton's steel plants. Aside from having a small fleet of rolling stock, the Timken Company is a leading manufacturer of roller bearings for railroad cars and locomotives.

R. J. Corman Railroad Group took over a former B&O line serving Massillon, Dover, and New Philadelphia in 1988. Ohi-Rail Corporation began providing freight service in 1982 on the former New York Central System Alliance Division.

Born in Germany in 1831, Henry Timken immigrated to the United States at age seven and later founded a carriage company in St. Louis. He experimented with nonfriction bearings and patented a tapered roller bearing on June 28, 1898. With his sons Henry H. and William R., Timken organized Timken Roller Bearing Axle Company. The firm moved to Canton in 1902 to be closer to steel mills and the center of the automobile production region. Timken commissioned the American Locomotive Company to build a 4-8-4-type steam locomotive with roller bearings on all axles that could be operated in passenger or heavy freight service. Numbered 1111, it was nicknamed "the Four Aces." Some steam locomotives had roller bearings on nondriving axles, but No. 1111 was the first with sealed roller bearings on all axles. (Courtesy of the Paul Vernier collection.)

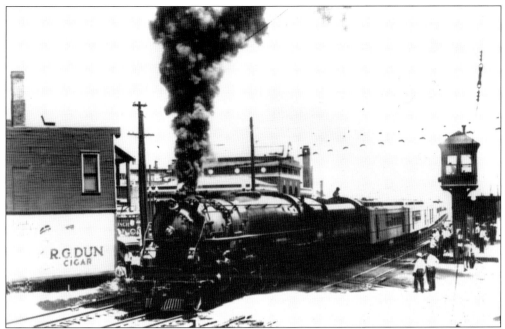

Timken's Four Aces entered service on May 14, 1930, and 14 railroads operated it over 100,000 miles. No. 1111 leaves the PRR station in Canton in the photograph above. To demonstrate how roller bearings produced so little friction that a locomotive could be pulled by hand, Timken had three men pull No. 1111 from a standing stop in both directions on level track (shown in the photograph below). Timken repeated the stunt with three women and with three children. The trials of No. 1111 were successful, but with the Depression curtailing locomotive production, sales of roller bearing–equipped engines lagged. The Northern Pacific Railroad acquired No. 1111 on February 8, 1933, and renumbered it 2626. Retired on August 4, 1957, the Four Aces was scrapped before an arrangement to bring it to Canton could be worked out. (Courtesy of the Paul Vernier collection.)

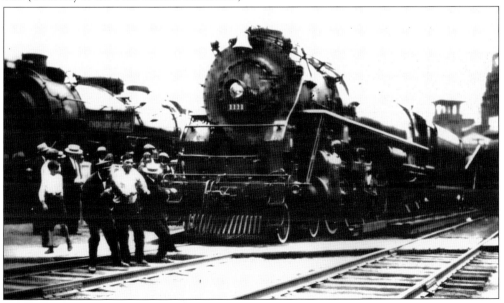

Timken Roller Bearing Axle Company experimented with roller bearings for railroad cars in 1922, placing them on an interurban railway car operating between Cleveland and Canton. Five years later, the Milwaukee Road equipped passenger cars on its *Pioneer Limited* with roller bearings. Timken made its first significant inroads in the freight car market with industrial and mining railroads, whose cars seldom operated outside their owners' properties. By the 1950s, Timken was Canton's largest industry as well as the world's largest roller bearing company. It had diversified into becoming a manufacturer of roller bearings, alloy and specialty steels, and related products. Timken also owned a small fleet of diesel locomotives and freight cars that it used at its Canton facilities. Now known as the Timken Company, it is still headquartered in Canton. (Above, photograph by Richard Antibus; below, photograph by John Beach.)

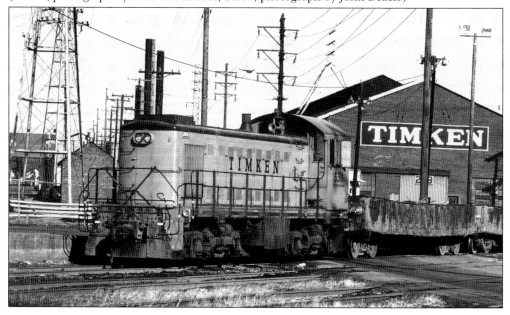

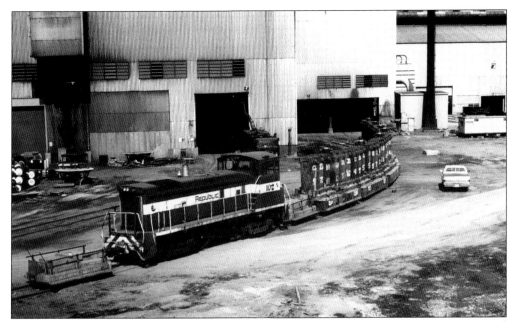

The Nimishillen and Tuscarawas Railway provided in-plant rail operations for Republic Steel factories in Canton, Lorain, and Massillon. It was subsequently renamed Republic N&T Railway and is a subsidiary of Republic Engineered Products, the successor to Republic Steel. Like most industrial railroads, Republic N&T operations were largely confined to its owner's property. A Republic switcher is shown working a plant in Canton. (Photograph by John Beach.)

The PRR line into the Timken roller bearing plant in Canton had a crossing with Timken-owned tracks that was protected by a target signal. A Conrail train still sporting a Penn Central caboose is at the crossing on March 18, 1978, perhaps getting instructions from Timken officials before entering the plant. The factory in the background is an oil refinery owned by Marathon Oil Company. (Photograph by John Beach.)

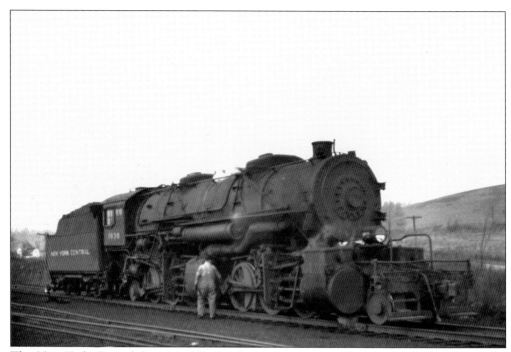

The New York Central System's Alliance Division was an orphan operation because it did not connect directly to the rest of the New York Central's system. Trains leaving the Alliance Division had to get onto the Erie Railroad at Phalanx or the PRR at Alliance. Trains reached the New York Central at Brady Lake or Youngstown. Typical of the steam power assigned to the division in the waning days of steam were 2-6-6-2s No. 1936, shown in the photograph above, and No. 1934, shown below at the Minerva roundhouse. These articulated locomotives were designed to haul heavy trains, particularly over less-than-ideal track. The Minerva roundhouse had been razed by the mid-1960s. Minerva achieved a degree of railroad fame in 1880 when a foundry owned by brothers I. N. and Willard Pennock built the nation's first all-steel freight car. (Photographs by Bob Redmond.)

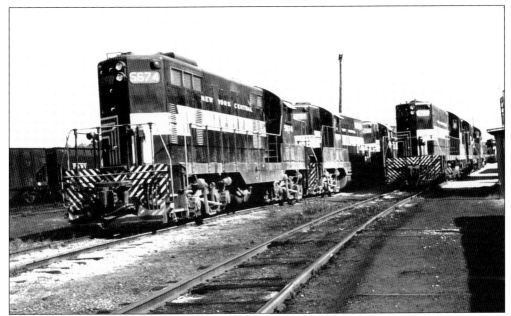

The New York Central phased out steam locomotives in the late 1950s, replacing them with diesels such as these GP7s shown at Minerva in May 1961. The Alliance Division was quite busy between 1958 and 1964, with trains serving three large mines. Through the 1970s, the line also served a number of strip mines, some of which operated on again, off again. (Photograph by John Beach.)

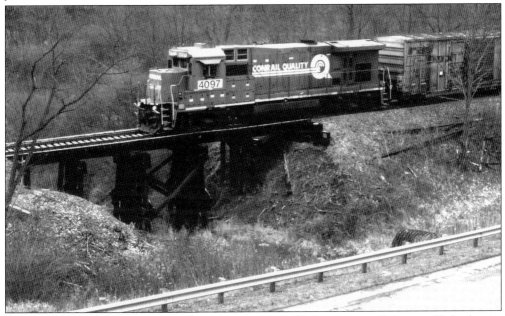

Conrail was established with the expectation that it would abandon or sell dozens of light-density branch lines such as the former Penn Central routes serving Minerva. After operating these lines for a few years, Conrail sold the Minerva–Hopedale line to the State of Ohio, which granted operating rights to Ohi-Rail Corporation. A former Conrail B23-7R pulls an Ohi-Rail train southbound near Mechanicstown on November 23, 2002. (Photograph by Jerry Jordak.)

Ohi-Rail Corporation began operating between Minerva and Hopedale on July 30, 1982, and acquired a former PRR branch between Bayard and Minerva in 1993. Principal commodities handled include kiln-dried hardwood lumber, pine lumber, plastics, wood waste products, and machinery. Ohi-Rail also provides car storage and transloading in Minerva. Historically, the Ohi-Rail routes carried large volumes of coal, which between 1977 and 1982 plunged from four million tons annually to virtually nothing. In the photograph above, Ohi-Rail No. 102 crosses the diamond of the former PRR and New York Central System routes in Minerva on January 26, 2002. In the photograph below, Ohi-Rail No. 101 leads a northbound train at Pattersonville on September 14, 2002. No. 101 and No. 102 are Alco S-2 switchers built in October 1945 and June 1946, respectively, for the Fairport, Painesville and Eastern Railway. (Photographs by Jerry Jordak.)

Richard J. Corman founded a railroad construction company in Nicholasville, Kentucky, in 1973. In 1987, he purchased a short rail line at Bardstown, Kentucky. R. J. Corman Railroad Group now operates over 700 miles of track in Kentucky, Ohio, Pennsylvania, Tennessee, and West Virginia. Corman purchased from CSX 50 miles between Clinton and Uhrichsville and began using it in December 1988. Major commodities hauled include paper, chemicals, brick, stone, and railroad supplies. On August 6, 2002, Corman purchased from CSX the 2.16-mile Wooster industrial track, which it reaches via NS from Massillon. In the photograph above, Corman GP16 No. 1804 and GP20 No. 4118 lead a northbound train at Butterbridge Road near Massillon on July 27, 2008. Below, No. 1804 leads a southbound train at Canal Fulton on June 26, 2008. (Above, photograph by Peter Bowler; below, photograph by Craig Sanders.)

R. J. Corman Railroad Group calls its Clinton–Uhrichsville line the Cleveland Line, even though it does not come close to Cleveland. Corman also owns four railroad routes in western Ohio. The Cleveland Line's operating headquarters is in Dover. In this March 1991 view along Warwick Road north of Canal Fulton, Corman GP9 No. 9004 pulls a train consisting primarily of tank cars bound for a Dover chemical plant. (Photograph by Marty Surdyk.)

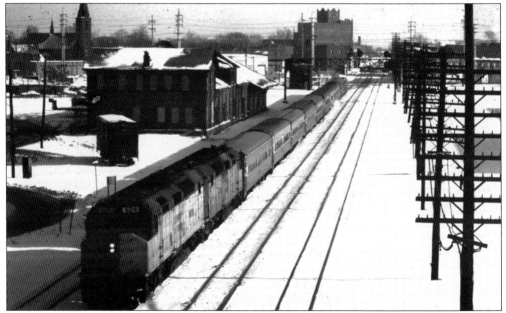

Amtrak's New York–Chicago *Broadway Limited* normally operated through Canton after dark, but poor Penn Central track conditions in the early 1970s made it habitually late. A tardy *Broadway* heads west after making its Canton stop in late January 1977. Leading the train is a pair of SDP40F locomotives, which were among the first new motive power Amtrak purchased after beginning operations on May 1, 1971. (Photograph by John Beach.)

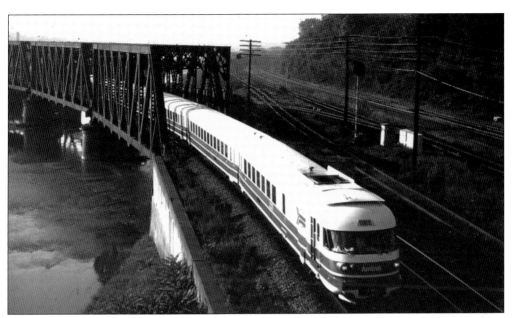

Amtrak leased a pair of turbine-powered trains from the French National Railways to use on Midwest corridor routes. The trains were ferried between Newark and Chicago in early August 1973, attracting crowds along the way. A turbo train, which Amtrak touted as possibly the biggest advance in travel since the 747 jumbo jet, is shown passing through Massillon. Turbo trains never served northeast Ohio in scheduled service. (Photograph by John Beach.)

After the former PRR Canton station was condemned by the city and subsequently razed, Amtrak agreed on April 22, 1977, to build a new station for $200,000 at the site. Construction began in early 1978, and the station opened on June 29. At the time, Canton averaged 26 passengers a day. The *Capitol Limited*, which received dome coaches in March 1983, is shown at Canton. (Photograph by Dan Davidson.)

The *Broadway Limited* and *Capitol Limited* passed through Alliance, but Amtrak did not begin boarding passengers there until November 12, 1990, when the *Capitol* was rerouted via Cleveland and service ended at Canton. An Amtrak publicity special is shown at Alliance in October 1994 promoting the assignment of Superliner equipment to the *Capitol Limited*. Amtrak's Alliance station is a bus stop–style shelter. (Photograph by Richard Antibus.)

Hoping to increase revenue by hauling express freight, Amtrak extended the New York–Pittsburgh *Pennsylvanian* to Chicago on November 7, 1998, stopping at Alliance (shown here) and Cleveland. The *Pennsylvanian* had a daytime schedule through Ohio, but patronage lagged due to poor arrival and departure times at Chicago and Philadelphia. Amtrak gave up on express business, and the *Pennsylvanian* last operated west of Pittsburgh on February 10–11, 2003. (Photograph by Marty Surdyk.)

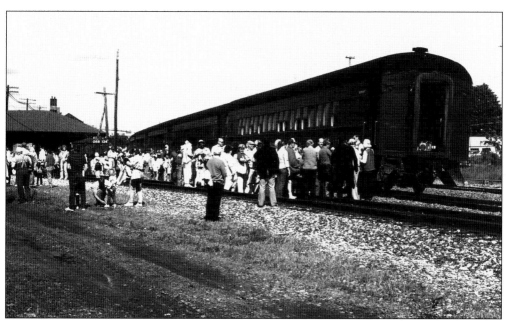

For its June 1988 Depot Days festival, the ORHS sponsored excursions that operated Canton–Orrville and Crestline–Orrville. The excursions carried nearly 1,400 passengers, but as the day wore on, the trains fell behind schedule. Conrail charged the ORHS three times what the organization had expected, and the trips wound up being a wash financially. The return trip to Canton is shown boarding at Orrville. (Photograph by Richard Jacobs.)

Howard Wade is a former chairman of the ORHS who helped save the town's railroad station. In 1982, Conrail agreed to sell the depot to the ORHS, but due to a miscommunication, a demolition crew showed up to raze the building. Wade, then an Orrville councilman, threatened to have the crew arrested. After a telephone call to Conrail, the demolition crew left. (Photograph by Richard Jacobs.)

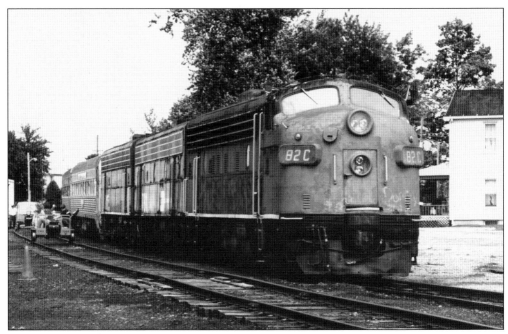

In the early 1980s, the ORHS purchased three F units that were used on short excursions over former W&LE trackage within Orrville. No. 82C is an F7A built for the Milwaukee Road in November 1951. The ORHS later sold it to the OC, and it is now owned by a North Carolina short line railroad. No. 82C is shown in Orrville on June 8, 1996. (Photograph by Craig Sanders.)

The ORHS acquired GP7u No. 471 in the spring of 2000 for excursion train use. Built in September 1950 for the Maine Central Railroad, it pulled Connecticut Department of Transportation–sponsored commuter trains before coming to Orrville. No. 471 is shown on August 11, 2007, next to W&LE GP36 No. 109, which is named for ORHS founder Robert S. Bixler, who died in April 2007. (Photograph by Craig Sanders.)

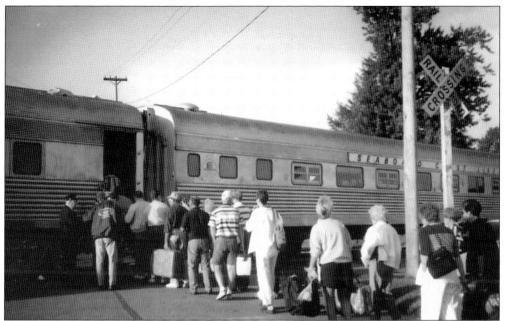

Since sponsoring its first excursion on June 26, 1982—a trip to Bellevue behind NKP steam locomotive No. 765—the ORHS has operated more than 125 excursions and carried thousands of passengers. Many of these trips have originated in Orrville and have featured the ORHS fleet of passenger cars. Some trips have traveled more than 400 miles while others have been about 2 miles. (Photograph by Richard Jacobs.)

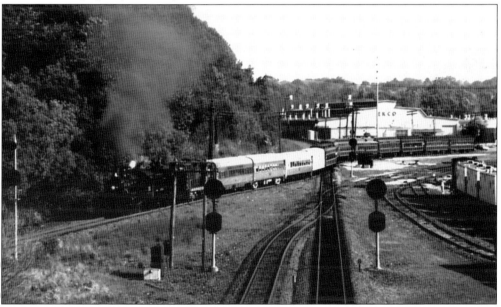

Many ORHS excursion trains travel over the tracks of the W&LE, which serves Orrville, or the OC. But only one trip has used R. J. Corman Railroad Group track. Shown crossing Conrail in Massillon is the June 13, 1993, *Canal Town Special* between Canal Fulton and Coshocton. Pulling the southbound train is OC steam locomotive No. 1551. Equipment included ORHS and OC passenger cars. (Photograph by Edward Ribinskas.)

The CVSR began seasonal excursion trains between Cleveland and Akron in 1975 on the former Valley Railway line. The National Park Service purchased the track north of Akron in 1987, while Akron Metro Regional Transit Authority purchased the line between Akron and Canton in May 2000 with the idea of preserving it for future commuter train use. The CVSR began summer Canton–Akron excursion service on July 12, 2003, operating on weekends from June through August. The Canton trains often used rail diesel cars, shown above. The park service funded the Canton station, built on land owned by the City of Canton on Tuscarawas Street West. Service expanded to daily except Monday and Tuesday in 2008 with schedules coordinated to connect with CVSR trains operating north of Akron. A CVSR train is shown below in Canton. (Photographs by Jerry Jordak.)

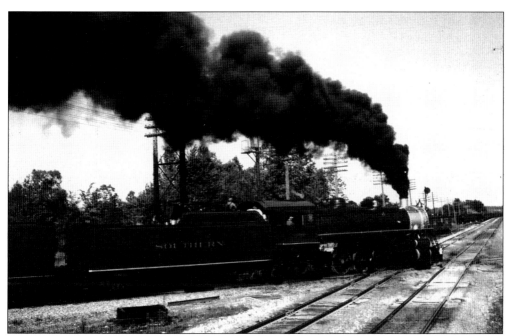

Former Southern Railway System No. 4501 is shown pulling the *Independence Limited*, a Chicago-to-Washington excursion train sponsored by the Roanoke Chapter of the NRHS. The train is crossing the Erie Lackawanna Railway at Creston on July 5, 1973. No. 4501 is a 2-8-2 Mikado type built by Baldwin Locomotive Works in November 1911 and retired by the Southern in 1948. (Photograph by Richard Jacobs.)

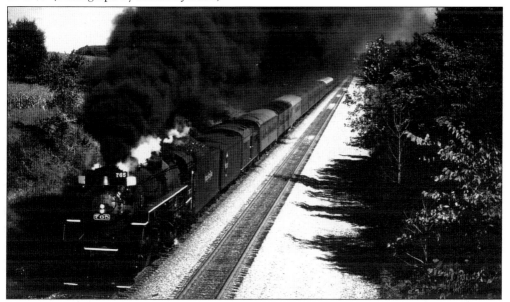

NKP No. 765 was built by Lima Locomotive Works in September 1944. The 2-8-4 Berkshire-type locomotive sat on static display in Fort Wayne, Indiana, until being restored by the Fort Wayne Railroad Historical Society and returning to service in 1975. No. 765 is shown at Back Orrville Road near Wooster in September 1988 en route to Huntington, West Virginia, on a deadhead move. (Photograph by Marty Surdyk.)

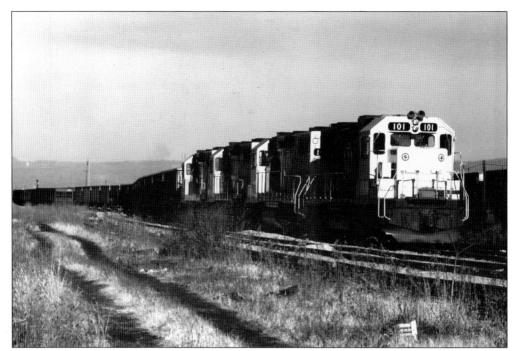

In 1975, Cleveland Electric Company leased nine GP38-2 locomotives to ensure that its unit coal trains would always have motive power available, which Penn Central could not always guarantee. These locomotives, along with 11 SD40s and 11 U30C diesels owned by Detroit Edison Company were regular sights on former PRR tracks through Alliance. A Cleveland Electric coal train is shown at Mingo Junction on December 20, 1979. (Photograph by Jeff Pletcher.)

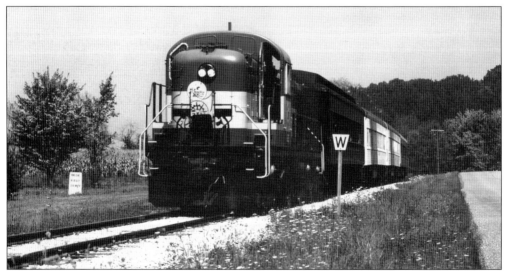

For several years, the Carrollton-Oneida-Minerva Railroad operated a weekend 22-mile round-trip seasonal excursion train between Carrollton and Minerva on the Carrollton branch of the W&LE. Named the Elderberry Line, the trains featured vintage diesels and coaches with a diversity of heritages. The Elderberry Line ceased operations after the 2003 season. No. 603, an Alco RS-3, leads the train in September 1998 near Minerva. (Photograph by Richard Jacobs.)

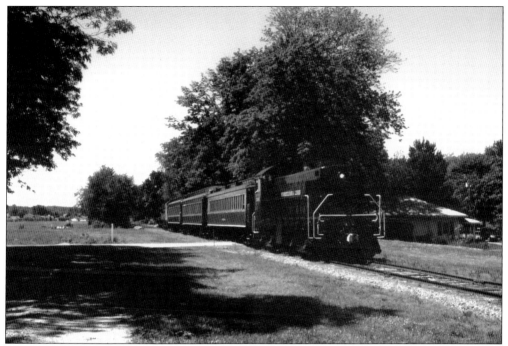

After the Elderberry Line folded, the Steam Railroad Museum in Minerva organized a tourist railroad that began in 2004 as the Minerva Scenic Railway, operating between Minerva and Bayard on the former PRR Tuscarawas branch. The service ran for three seasons before being cancelled in 2007 due to rising costs of fuel, advertising, and insurance. A switcher painted in PRR colors leads a train at Minerva. (Photograph by Jerry Jordak.)

The late Perry C. Willis operated a miniature railroad on his farm near Alliance. The railroad's initials stood for Puff, Chug and Whistle and were also Willis's initials. The authentic steam locomotives were powerful enough to pull small passenger cars. In this August 2, 1964, view, the PC&W is running a steam doubleheader. The lead locomotive is a 4-4-0. (Photograph by James McMullen.)

ACROSS AMERICA, PEOPLE ARE DISCOVERING SOMETHING WONDERFUL. *THEIR HERITAGE.*

Arcadia Publishing is the leading local history publisher in the United States. With more than 3,000 titles in print and hundreds of new titles released every year, Arcadia has extensive specialized experience chronicling the history of communities and celebrating America's hidden stories, bringing to life the people, places, and events from the past. To discover the history of other communities across the nation, please visit:

www.arcadiapublishing.com

Customized search tools allow you to find regional history books about the town where you grew up, the cities where your friends and family live, the town where your parents met, or even that retirement spot you've been dreaming about.